AIRBRUSH 2

Concepts for the Advanced Artist

Radu Vero
AIRBRUSH 2
Concepts for the Advanced Artist

WATSON-GUPTILL PUBLICATIONS/NEW YORK

Copyright © 1985 by Watson-Guptill Publications

First published 1985 in New York by Watson-Guptill Publications,
a division of Billboard Publications, Inc.,
1515 Broadway, New York, N.Y. 10036

Library of Congress Cataloging in Publication Data

Vero, Radu.
 Airbrush 2.

 Includes index.
 1. Airbrush art—Technique. I. Title. II. Title:
Airbrush two.
NC915.A35V46 1985 751.4'94 85-13878
ISBN 0-8230-0167-9

Manufactured in Japan

First Printing, 1985

1 2 3 4 5 6 7 8 9 10 / 90 89 88 87 86 85

To the memory of my mother
who gave me everything.

Acknowledgments

Without the initiative and encouragement of David Lewis and Mary Suffudy of Watson-Guptill this book would not have been written. The editing of Susan Colgan was a valuable contribution as well. If the readers find the text instructive, it is because of her ability to simplify and clarify complex and sometimes confusing statements.

The theoretical aspect of the book was enhanced by the intelligent and constructive criticism of Lydia and Daniel Gassman and Cheryl Shelton. I am, however, solely responsible for any controversial statements that remain. Last but not least, I am indebted to Kathy Ann Miccio for her substantial help in the preparation of the illustrations.

Introduction

If you look at the four lines in Figure I-1, each done in a different medium, you will most probably be able to express a preference for one medium over another. Or, if you are asked to select your favorite tonal application of a medium (Figure I-2), you will have no trouble doing so. In both cases you are stating a preference, but what is the logic or rationality behind that choice? What *really* makes you like one better than the other? The answer comes only after you achieve a basic understanding of the behavioral mechanism of visual stimulus and response.

Similar to the response made by Pavlov's dog, an artist responds to an onslaught of visual stimuli. These stimuli, through a very complex neural mechanism, trigger a positive or negative response. For example, the color red can elicit a positive response from a person who believes in communism, or a negative one from a person who deplores it. Moreover, this stimulus—the color red—can change from positive to negative for the individual who once loved communism but later felt oppressed by it.

Form is also affected by our preconditioning. A bold, vigorous brushstroke might be interpreted by some as energetic and forceful and therefore positive; whereas the same stroke will be seen as crude and violent and therefore negative to others.

These interpretations depend upon the individual's history and, of course, there are enormous variations in response from one person to the next. But a preference for a certain medium is not arbitrary; it is determined by an affinity between the artist and the particular stimuli expressed by that medium. This preference is subjective; it can't be analyzed; and it is particular to each individual.

The choice of airbrush for the students of this book must begin with the simple statement, "I like it!" Airbrush should not be chosen for its speed or professional advantages

alone. Whether the positive response to airbrush is triggered by its incomparable smoothness, its brilliant tones, or its delicacy, there must be a genuine love for airbrush—for the versatility and extraordinary qualities generated by this unique medium.

CONCEPT

Concept plays a vital role in *Airbrush 2*. Theories and analyses of concept abound and the term is rather flexible in its use, but in general, concept is defined as an idea, especially one derived from specific instances or occurrences. And for our purposes, it is defined within the realm of visual artistic creativity. By this I mean artists must have an initial idea about what they intend to convey *before* they translate that idea into visual form. Thus, you can have a concept of "cat," but you cannot have the concept of Morris-the-cat, who is real. You can observe and examine one thousand real cats and then form a concept of "cat" by abstracting those characteristics that all cats have in common. And since no one has ever seen *all* the cats in the world, you might speculate that some cats are green—and there would be no absolute proof that green cats don't exist.

Concepts are logical structures of abstracted and assembled generalities. In the process of building the concept of cat, the preexistence of other concepts—such as the concept of vertebrates—is supposed. And in order to have the concept of vertebrates, you must have the concepts of muscle and bone, and so on. At some point, the chain of concepts will end, and you will come to a barrier beyond which there is nothing but assumptions, and hypothesis, and beliefs, all of which belong to the nonrational, emotional universe of our brain. For any individual, regardless of innate abilities, level of education, or social conditioning, there is a conceptual barrier level,

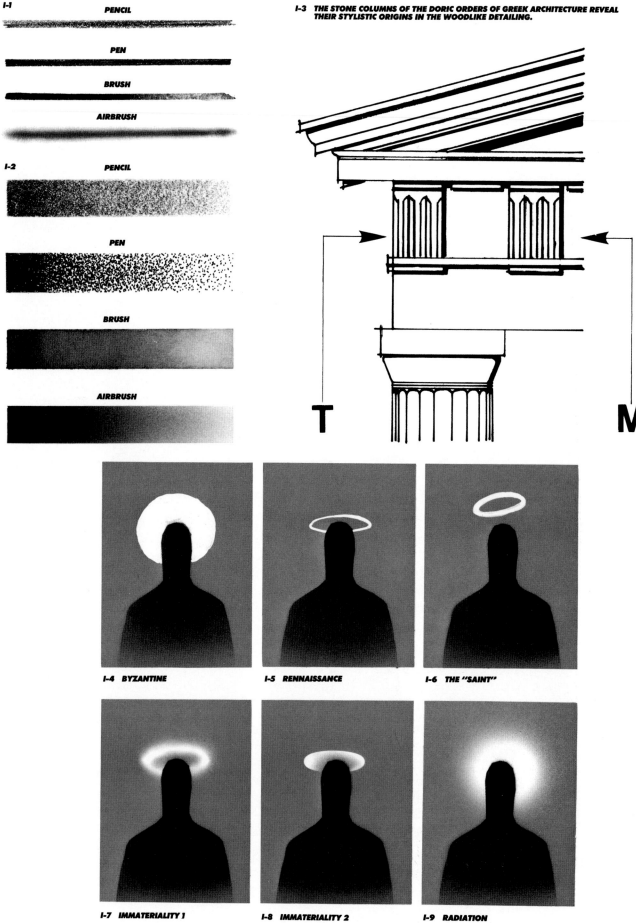

I-1

PENCIL

PEN

BRUSH

AIRBRUSH

I-2

PENCIL

PEN

BRUSH

AIRBRUSH

I-3 THE STONE COLUMNS OF THE DORIC ORDERS OF GREEK ARCHITECTURE REVEAL THEIR STYLISTIC ORIGINS IN THE WOODLIKE DETAILING.

T

M

I-4 BYZANTINE

I-5 RENNAISSANCE

I-6 THE "SAINT"

I-7 IMMATERIALITY 1

I-8 IMMATERIALITY 2

I-9 RADIATION

beyond which uncertainty prevails. It is because of these barriers that even seemingly logical structures are often founded on uncertainty.

Personal history is probably the most important factor in determining differences in concept. For the person who loves cats, the concept of cat is positive, but for those who fear cats, the concept is negative. For people who have inherited the tradition of worshiping cats as divine presences on earth, the concept of cat is profoundly different from the concept of cat produced by an urban, secular society. And without these illogical, subjective determinants of a concept, art wouldn't exist and an artist's message would be nonsensical because it would be devoid of a personal, conceptual foundation.

It is essential to understand that the first creative act is the mental vision of the message or goal of the work of art. The intellectual process of concept is very personal, and artists who do not have their own emotional impulses and concepts are always in debt to fellow artists who do. The creative artist motivated by personal vision knows no restrictions in pursuing a goal. There is a great difference between painting a green cat in order to appear original and painting it green because it is the most appropriate color for communicating the artist's message.

THE ROLE OF AIRBRUSH IN ART

What is the role of the airbrush in contemporary art? There are many misconceptions about the airbrush medium. Many people think of it as a medium suitable only for commercial art. But airbrush is a means to an end, like any other medium used for artistic expression. Its mastery can be achieved by most people who are willing to take the time to become a good technician. Conceptual airbrushing, however, requires more of a commitment from the artist because it does not depend solely upon learned technique, but instead relies on the artist's ability to precisely conceptualize a work of art. In the case of fine artists, they enjoy a freedom that cannot be restricted by anything except a self-imposed responsibility toward society. On the other hand, commercial artists must necessarily predetermine the reactions of the prospective audience; they must have a very clear and well-thought out idea about a subject. Above all, both fine and commercial airbrush artists must be innovative, because the medium itself adds a new dimension to visual communication. A line made with a brush is profoundly different from a line made with an airbrush gun; not only are two techniques demonstrated, but two messages are conveyed as well.

Airbrush brings to painting a new artistic vocabulary, which is probably the reason why this medium has made such slow inroads into the world of fine art. It is with very few exceptions that contemporary artists are able to visualize new messages through the airbrush language. They merely adapt old techniques to a new medium and often are imitating styles that were developed with other media. To offset society's tendency not to appreciate the full potential of airbrush, it is essential to educate both the art community and the culture at large.

First, artists need to develop more control over the airbrush medium. Since artists typically discover airbrush at an age when the habit of using pencil and brush dominates their process of visualizing, they merely adjust their vision to the new instrument with little hope of developing airbrush concepts. But the study of airbrush should begin early in the life of an artist. Thus, by the time an artist reaches intellectual and artistic maturity, his or her technical mastery will be quite advanced.

Second, society needs more exposure to airbrush imagery. This exposure has to some extent been achieved, namely by the advertising industry, where airbrush technique is used quite extensively. It is, however, an inadequate conditioning because the artistic quality of commercial airbrush work is often imitative of other media and not "art" in its truest sense. And in many cases, the technical skill of the airbrusher is so refined and imitative, it is difficult to know if the work is really a photograph or a super-realist painting.

Of course, imitating the style of an earlier technology is a phenomenon known since antiquity. For example, when the Greeks discovered the art of masonry, they began to replace wooden columns with stone columns. These stone columns, however, reflected the material and design detailing of wood, not stone. (See Figure I-3.) But until a medium can express itself fully through its own unique language, it is not a fully developed art form.

Another example of changing concept and medium concerns the development throughout history of a very recognizable symbol—the halo or spiritual aura. During the Byzantine era, an aura was interpreted as a simple circle (Figure I-4). After the advent of perspective, however, the halo was tilted at different degrees in order to emphasize its three-dimensionality (Figure I-5).

In modern times, the symbol of spiritual aura has sometimes been depicted in a tongue-in-cheek fashion (Figure I-6) as the "saint," or as a representation of the incorporeal (Figures I-7, I-8). This immaterial realm is one of airbrush's major strengths, for what other medium can better express the visualization of spiritual essence—or, for that matter, such a reality-based and scientifically informed concept as that of radiation (Figure I-9). Airbrush, of course!—a medium that has the capability to flawlessly express the imagination of modern man and the abstractions of the latest scientific research. Airbrush is a new vocabulary in the language of art, and its appearance in the twentieth century is no accident. Given the chance, this new medium will spawn the finest artists of the next century.

Radu Vero

How to Use This Book

This section introduces a basic airbrush vocabulary, which consists of terms that you will need to follow the exercises in this book. This vocabulary is essentially an expansion of the terms used in *Airbrush: The Complete Studio Handbook* (published by Watson-Guptill Publications, 1983). You will also be presented with symbols for color combinations, formulas for expressing complex mixing operations, and some characteristics about certain colors.

Many a profession, because it involves a group of people with a shared experience, has developed its own vocabulary, or professional jargon, and often a specific code of symbols. This vocabulary or code facilitates understanding and speeds up the exchange of information. Music is an excellent example, and mathematics, of course, is another.

Because of its technical nature, much airbrush information can be condensed into a code. The codes presented here are designed to make the exercises that follow easier to convey. But remember, these codes serve only in the education of the artist who wishes to master advanced procedures in airbrush painting. They are not designed to interfere with the creative process.

In the exercises throughout this book you will learn to establish your colors and the intensity of those colors by numerical percentages. But later, as an artist, you will determine colors and the qualities they impart according to your own feelings and sensibilities, bringing to the work at hand the knowledge gained in this study.

APPLICATION SEQUENCE

When you begin to study the exercises in this book, start your analysis by looking at the final renderings and try to figure out the strategy. Then begin with step 1, which indicates the first application of spray, and continue on through all the steps listed. Remember, every single line gives you all the information you need to complete a single application.

TYPE OF MEDIUM

To indicate the type of medium used, the following symbols will appear: (O) for opaque color (gouache or acrylic) and (T) for transparent color (watercolor, dye, ink). Given this coding system, a fairly complex notation can be written in a simple way. Instead of "use transparent media 50 percent red plus 50 percent yellow, and spray a flat surface at 80 percent density," you will see (T) $50Rd + 50YD_{80}$.

TECHNIQUE

In order to explain precisely which techniques are required for any of the exercises, the following symbols are used:

BRUSH	B
AIRBRUSH FREE	F
AIRBRUSH MASK	M
AIRBRUSH SHIELD	S
AIRBRUSH TEMPLATE	T

COLOR CODING

To further simplify the notations in the exercises, the following palette of 32 colors will be represented by 27 color codes. (The color names are the same as those used for Winsor and Newton's designers' gouache paints.) In several instances (Rd_1, V, and Bk, for example), two or three basic colors are listed under the same code. This has been done intentionally, because some of the colors are similar but not exactly so. This gives you alternatives and therefore the opportunity to choose which color best illustrates your point.

In the practice exercises you do not have to obtain the mathematically precise tones, nor must gouache invariably be used. The color will be indicated, but the medium can vary. You can also use watercolors, inks, dyes, acrylics, or even oil, as long as the color coded mixture you want is obtained. The given combinations must be considered suggestions, not rules. With color choice nothing is rigid.

Here are the colors and their respective codes:

RED (Rd) Rd_1 = scarlet lake, flame red
 Rd_2 = magenta
 Rd_3 = madder carmine
 Rd_4 = rose tyrien, Bengal rose
 Rd_5 = Havannah lake

ORANGE (Co) Co = cadmium orange

YELLOW (Y) Y_1 = spectrum yellow
 Y_2 = lemon yellow
 Y_3 = yellow ochre

BLUE (Bl) Bl_1 = cobalt blue
 Bl_2 = ultramarine
 Bl_3 = turquoise
 Bl_4 = cerulean blue
 Bl_5 = Winsor blue

GREEN (G) G_1 = Winsor emerald
 G_2 = olive green
 G_3 = oxide of chromium
 G_4 = Winsor green

VIOLET (V) V = Parma violet, light purple

BROWN (Br) Br_1 = raw sienna
 Br_2 = burnt sienna
 Br_3 = raw umber
 Br_4 = burnt umber
 Br_5 = Van Dyke brown

BLACK (Bk) Bk = jet black, ivory black, lamp black

WHITE (W) W = permanent white, zinc white

Now you can see that color combinations, i.e., the basic combinations or mixtures of colors to be poured into the airbrush cup, can be written in a much simpler fashion than before. For example, in my first book an application of paint was expressed as: 70 percent permanent white + 20 percent yellow ochre + 10 percent cadmium orange. With the color code, the same formula can be simply noted as follows: $70W + 20Y_3 + 10Co$.

RESOLUTION

An important factor to consider when dealing with surfaces is their definition against the adjoining surfaces or background—or their degree of *resolution*. Resolution (R) is designated as R_1 through R_{10}. R_1 represents the sharpest degree of resolution with a linear division between black and white, i.e., R_1 means a distinct, sharp contrast between the two colors; R_{10} represents the least definitive resolution, i.e., a hazy division between black and white. For example, a notation indicating a resolution of 2 will be written as R_2, where there is a range of resolution (let's say, between 2 and 7), the notation will read R_{2-8}.

DENSITY

In printing, the *density* of a color is measured by the percentage of dots per-square-inch, as illustrated in Figure II–1. We will borrow this system for airbrush to indicate the density of microscopic drops of paint sprayed in order to obtain a paler or darker tone upon an existing background. Density will be written here as D.

For example, if black paint is sprayed on white paper at 50 percent density, a medium gray will be the result (Figure II–2); or if we spray 30 percent density red on 100 percent density yellow a light orange is obtained (Figure II-3).

If an area requires a subtle gradation of color, an arrow is used to indicate which direction the gradation is going. For example: 1. $D_{50} \leftarrow D_{100}$ indicates that the color density on the left side of the art is 50 percent less than on the right side, which is at 100 percent. 2. $D_{50} \rightarrow {}_{100}$ indicates that the application requires tones that gradate from 50 percent to 100 percent, although not specifically from one direction to another, but only where the illustration requires such percentages. (See example in Figure II–4.) 3. If a tone must be gradated, an arrow pointing in the direction of lighter value will be indicated. These arrows will be shown pointing from left to right →, right to left ←, top to bottom ↓ or bottom to top ↑.

If an illustration is complex, such as renderings of organic forms, and requires various degrees of density that are not necessarily gradated, then the notation will indicate density values without specifying direction. For example, the notation D_{0-100} tells us that the minimum density used is 0 percent and the maximum is 100 percent.

SATURATION

To obtain 100 percent density (D_{100}), you must cover the entire support surface, leaving no background visible. Thus, in airbrush work, when you cover a surface with multiple layers of one color, you will get an altogether different result than if you apply one (D_{100}) layer. This effect is called *saturation* and is designated as S. The layering of pigment gives a deeper, more opaque, and often more brilliant color, depending upon the nature of the pigment used.

SPECIAL PROPERTIES

Certain colors have special characteristics or properties that can present the inexperienced airbrush artist with difficulties.

Toxic colors: Co, Bl_3, V (Parma violet), Bk (jet black) Due to the dangerous vapor forming action of the airbrush, toxic colors must be used with caution. Unfortunately, the above four toxic colors have no equivalent; they can hardly be replaced, but it is wise to avoid them when possible. Never use these colors to achieve a very weak resolution (R_{10}) or with your airbrush spraying at maximum pressure. Both instances release too much toxic paint into the air you breathe. Be aware that dye-based colors in gouache, watercolors, or inks are generally more toxic than the color based on pigments.

Weak colors: Rd_3, Rd_4, Y_1, Y_2, Bl_4, and V (violet) Use these colors either on very light backgrounds (if not white) or mix them with a drop of white before spraying

on dark backgrounds to increase opacity. In order to produce D_{100} or S these colors need to be sprayed tenaciously for a long time and in many layers.

Difficult colors: Y_3, Bl_4, Br_{1-4}, Bk

These colors tend to clog the airbrush much faster than the other colors in our palette. Black creates an especially unpleasant problem by refusing to yield fine, uniform spray lines. For the best results these colors must be thoroughly diluted and mixed well with water and then quickly sprayed.

NOTE: The illustrations in this book are not retouched; you can, therefore, carefully observe the phases of work before the final polishing has been done. You may also observe that some details differ slightly from one step to another. This is because each step has been rendered separately in order to show you the clearest possible evolution of the work. To preserve the identity from one application to the next in a given exercise, the mask technique instead of the shield technique has been used frequently and more often than is normally required of the exercises.

It is important to remember that the indications about procedure explain how the work was done and by no means how it should be done by you. For instance, if at a certain stage in an exercise, the code indicates that in order to paint a white circle on a black background, you are to paint the black background first and then spray on the circle of white. If you like, however, you can change the procedure by first masking the circle on the white support and then spraying the black all around it. The decision to create this circle in a certain way is determined by the general strategy for the completion of the work. But this is a decision only the artist can make; and you are required to imagine as many strategies as possible for each illustration.

Assignment

To test your skills with the coding system, try to solve the following problem: Suppose you are asked to spray a light warm pink over a colorful surface. How would you write the formula-solutions in code?

As is often the case, this problem can be solved in several ways; each of these formulas expresses the solution in slightly different ways.

1. (O) $50Rd_1$ + $50W$ D_{100}
2. (O) $100Rd_1$ D_{50}
3. (T) $100Rd_1$ D_{80}

Thus the translations of the three formulas are: (1) Premix an opaque medium: scarlet lake or flame red with white and spray mixture over the surface completely; (2) Premix an opaque medium: scarlet lake or flake red and spray it at 50 percent density to get a halftone; (3) Premix a transparent medium: scarlet lake or flame red and spray it at more than 50 percent density to achieve a transparent effect. The first solution covers everything; the second creates a semi-transparent or transluscent effect; and the third preserves transparency entirely and only changes the color of the surface slightly.

II-1 DENSITIES

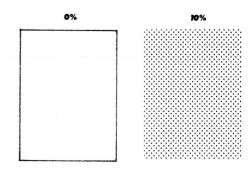
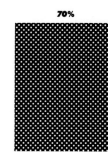

0% 10%

60% 70%

II-2

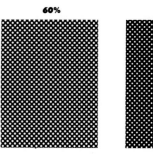

50% BLACK

II-4

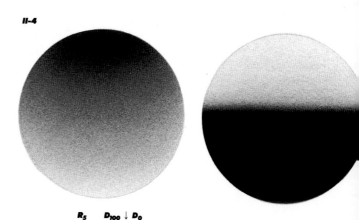
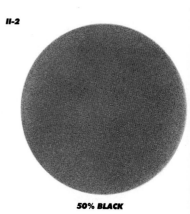

R_s $D_{100} \downarrow D_0$

20% **30%** **40%** **50%**

80% **90%** **100% (SOLID)**

II-3 STEP 1: 100Y STEP 2: 30 Rd₁ D₃₀ → D₁₀₀

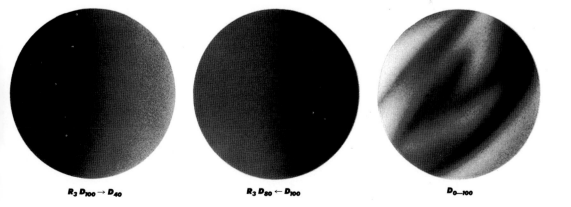

$R_3 D_{100} \rightarrow D_{40}$ $R_3 D_{80} \leftarrow D_{100}$ D_{0-100}

Part One

Light

Chapter 1

The Nature of Light

How do we see? Light is something we are aware of—at some level—every moment of our waking life, without (for most of us) our knowing how it's transmitted or how it's detected by our nervous system. Centuries of effort, investigation, and experimentation have led scientists to believe that light is a combination of waves and particles. Putting aside a more scientific analysis of this phenomenon, it can be simply said that our vision cells—our eyes—specialize in detecting light and also in detecting the number of light particles and the wavelength or frequency of the light waves. A greater or smaller number of particles is measured by our eyes as the intensity of light we receive, a longer or shorter wavelength is received as different colors. Thus, the visual information we receive, which is essential for survival, is very rich and detailed.

Let us return to our initial question: How do we see? We understand that only particles and waves hitting the retina produce light perception. Light is therefore our interpretation of a particle-wave bombardment of the retina. However, if particles and waves of light pass across our eyes, *we do not see them.*

In order to visualize this point, look at Figure 1–1, where the light is passing in front of the eye, and therefore nothing is perceived. In Figure 1–2, however, the light is penetrating the eye and exciting the retina. This is the way vision is activated.

The beam of light created by a flashlight in a dark room seems to contradict the idea that light itself cannot be seen (Figure 1–3). However, even though it may appear as though we are seeing light, we are actually seeing the dust and air molecules hit by lightwaves and light particles, which are scattering light in all directions. This is an important idea to remember when interpreting light through the airbrush medium.

By contrast, if you are rendering an atmosphere where there are few reflective objects and no atmospheric particles, such as the vast realm of space beyond the earth's atmosphere, the sun should be interpreted as a blinding globe of light, surrounded by a universe of black. However, the sun seen from earth, no matter how clear the day, is rimmed by a haze of reflected atmosphere.

1-1

1-2

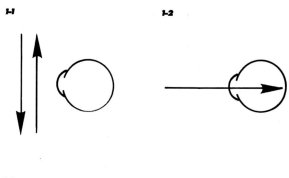

1-3

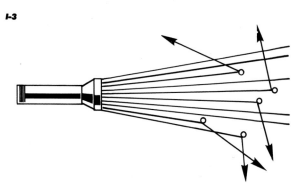

Chapter 2

Sources of Light

L ight is received in two ways, either directly from a source such as the sun, an electric light bulb, or a candle (Figure 2–1); or from light-reflective objects such as the moon, the air, the sea, etc. (Figure 2–2). The airbrush medium is a very successful tool for illustrating the various ways we perceive light. For example, in Figure 2–3, a diffuse ray of light travels over a black background; the subtlety of floating dust molecules reflecting and scattering the light is captured in two simple applications. Similarly, the more linear and condensed laser beam of light (Figure 2–4) is executed with two concentrated applications, in this case, flame red followed by cadmium orange.

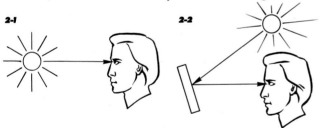

Figures 2–5 and 2–6 illustrate the difference between the sun seen through atmosphere or the sun seen from outer space. Here, again, airbrush is an excellent medium for capturing the exact look of the sun's corona and for describing the reflected or atmospheric gradations of light surrounding the sun.

As we know, heat is a source of light. Figure 2–9 is a step-by-step example of the transitions that a metal rod goes through as it becomes hotter and hotter. Airbrush is able to portray the hazy distinctions of changing color that transforms the rod. In Figure 2–7, the heat given off by a lighted match is created by a three-step airbrush application of rose tyrion, scarlet lake, and spectrum yellow.

Assignment

Render translucent light (from a source such as a small bulb, match, candle, etc.) that is shining through a pink and green screen, as shown in the drawing.

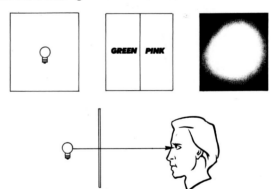

The problem is relatively simple. Because the light shade (vellum) is a screen interposed between the source of light and the eye, it will receive circular illumination from the source, diffused by the uneven structure of the vellum, with a stronger light at the center or source of light. If the light source is white and the vellum is a light gray tone, the finished rendering of such an image will look darker around the edges and lighter in the center. For this assignment, however, the vellum is not gray but is divided into a pink half on the right and a green half on the left. To illustrate the light coming through these two colors, use the following sequence of formulas:

1. Ⓜ (O) $80Rd_4 + 20W\ D_{100}$ (right side)
2. Ⓜ (O) $80G_1 + 20W\ D_{100}$ (left side)
3. Ⓕ (O) $100W + R_{10-2}\ D_0$ to center S

or

1. Ⓜ(O) $50Bk + 50W\ D_{100}$
2. Ⓜ(O) $100W\ R_{10-2}\ D_0$ to center S
3. Ⓜ (T) $100G_1\ D_{20}$ (right side)
4. Ⓜ (T) $100G_1\ D_{20}$ (left side)

2-3 Diffuse Beam of Light in Dark Atmosphere

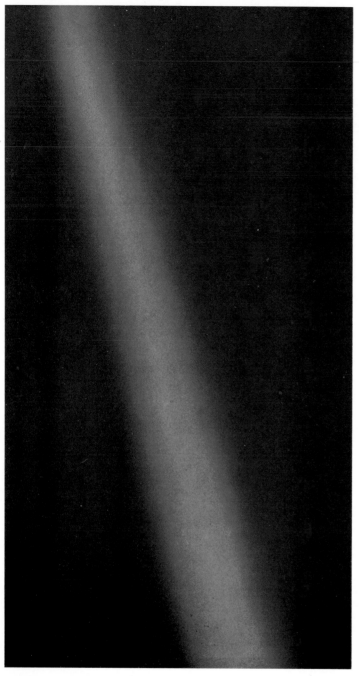

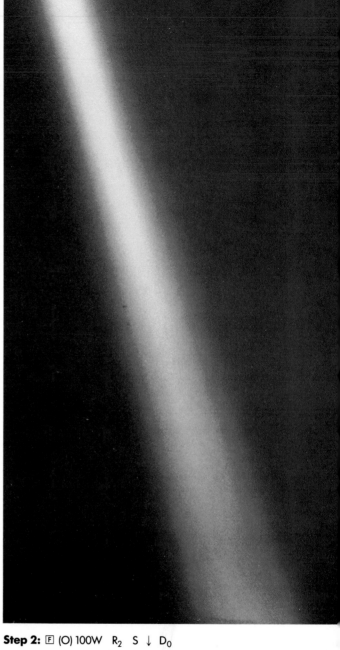

Support: 100Bk

Step 1: \boxed{F} (O) 80W + 20Bk R$_4$ D$_{100}$ ↓ D$_{50}$

Step 2: \boxed{F} (O) 100W R$_2$ S ↓ D$_0$

Concentrated Beam of Light (Lasar) in Dark Atmosphere

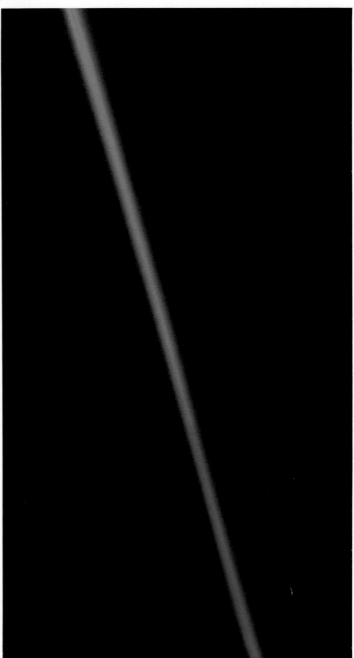

upport: 100Bk

tep 1: F (O) 100Rd$_1$ R$_3$ D$_{100}$

Step 2: F (O) 100Co R$_2$ S ↓ D$_0$

Note: Use ruler to guide airbrush.

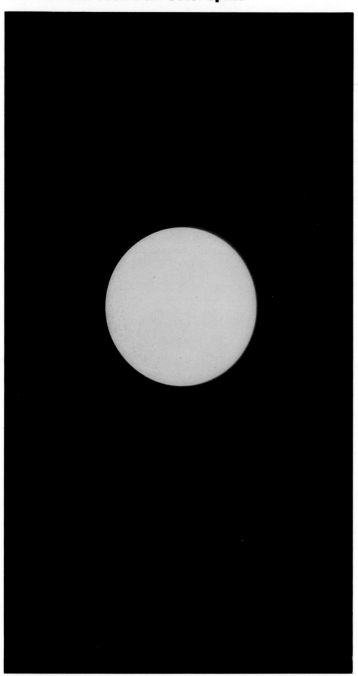

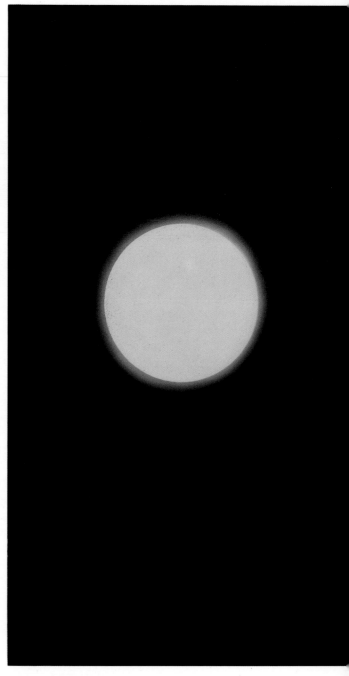

Support: 100Bk

Step 1: Ⓣ (O) 90W + 10Y$_2$ S

Step 2: Ⓕ (O) 90W + 10Y$_2$ R$_2$ D$_{10}$

Support: 100Bl₄

Step 1: ⑤ (O) 50Bl₄ + 50W R₅ D₁₀ → S(center)
Step 2: ⑤ (O) 70W + 30Y₂ R₃ D₁₀ → S(center)

Step 3: ⑤ (O) 100W R₂ S(center)

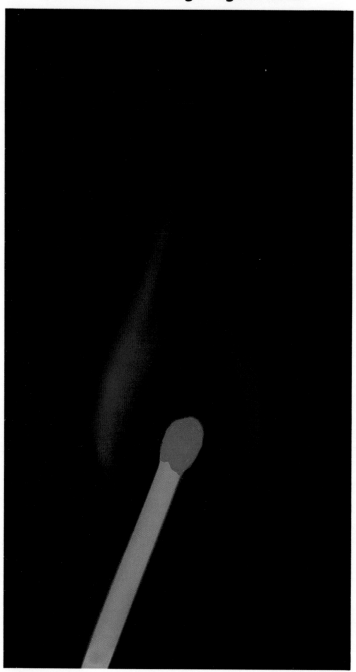

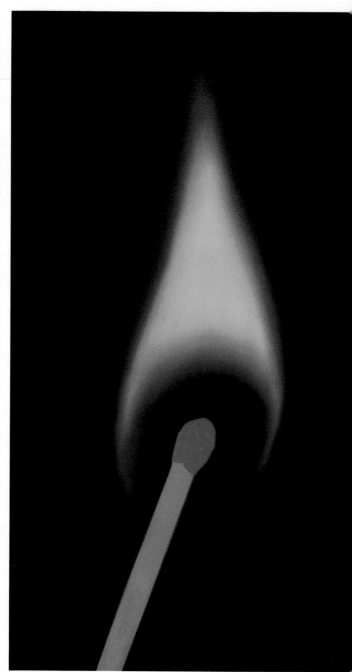

Support: 100Bk

Step 1: ⬜B (O) 30W + 70Br₁(matchstick)

Step 2: ⬜B (O) 100Rd₄(head of matchstick)

Step 3: ⬜F (O) 50Rd₄ + 50Bl₁ R₂ D₅₀

Step 4: ⬜F (O) 100Rd₁ R₂ D₁₀₀

Step 5: ⬜F (O) 100Y₁ R₂ D₁₀₀ → S

Support: 100Bl$_1$

Step 1: ⑤ (O) 50Bl$_4$ + 50W R$_5$ D$_{100}$ ↑ D$_0$

Step 2: ⑤ (O) 100Rd$_4$ R$_4$ D$_{100}$ ↑ D$_0$

Step 3: Ⓜ (O) 100Br$_2$ R$_4$ D$_{100}$ ↓ D$_{50}$

Step 4: Ⓜ (O) 100Co S

 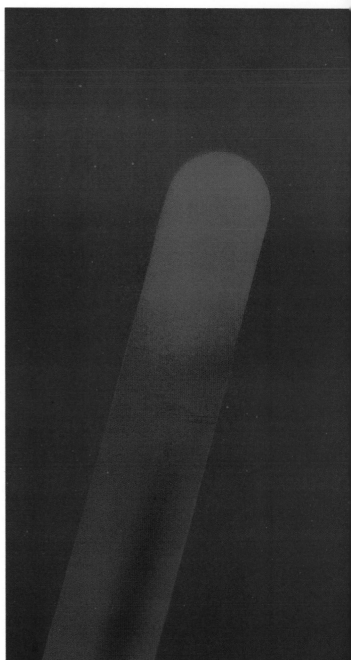

Support: 100Bl$_2$

Step 1: Ⓜ (O) 20W + 10Bk + 70Bl$_3$ D$_{100}$
Step 2: Ⓜ (O) 10W + 30Bk + 60Bl$_3$ R$_2$ D$_{60}$

Step 3: Ⓜ (O) 100Rd$_4$ D$_{100}$ ↓ D$_0$
Step 4: Ⓜ (O) 100Rd$_1$ D$_{100}$ ↓ D$_0$

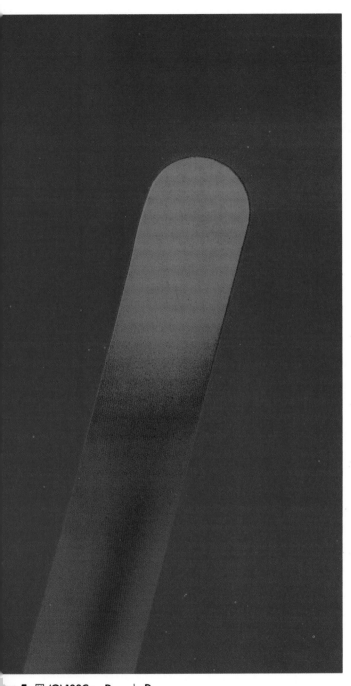

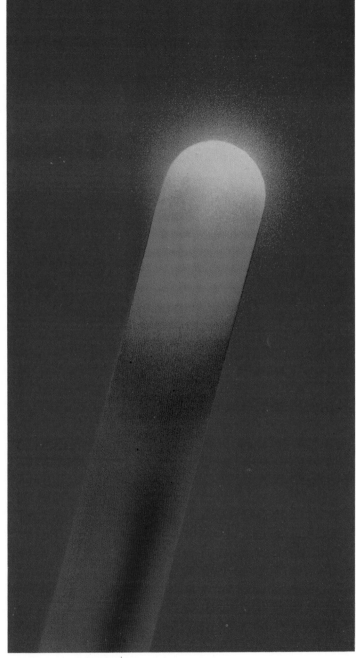

ep 5: Ⓜ (O) 100Co D_{100} ↓ D_0
ep 6: Ⓜ (O) 100Y₁ D_{100} ↓ D_0

Step 7: Ⓜ and Ⓕ (O) 100W S and radiant R_2

Chapter 3

Intensities of Light

Light comes to the eye with different intensities, and the intensity depends on the number of particles, or photons, that the eye perceives. The number of photons traveling from the source to the eye can be reduced by filtration, absorption, the angle of reflection, and by scattering. (Figure 3-1a, b, c, d illustrates various ways that light can strike and then reflect off a surface.)

FILTRATION

Light is filtered by substances interposed between the light source or reflection of the light source and the eye. These substances can be molecules of dust or gas, air or rain, glass or any thick transparent materials such as clouds or fog, which absorb and scatter the photons. Compare the light quality of Figure 2–7 wth the same subject—a lighted match—as seen through various colored glasses and transparent cloths (Figure 3–7).

ABSORPTION

Because objects exist in a multitude of materials and come in all colors, they also reflect light to various degrees. Theoretically, a black object absorbs all the light particles. However, a shiny metallic black object reflects more light than a black object with a matte surface. Light-colored, shiny objects reflect the most light and absorb the least. Thus, to illustrate a red silk scarf you must show a great deal of reflected light.

When rendering landscape elements, remember that atmosphere reflects or absorbs light in varying degrees. Notice that in Figure 3–9, the skyline is seen in sharp relief and must be rendered using the mask technique. By contrast, when illustrating buildings obscured by fog (Figure 3–10), their outlines are almost imperceptible and will probably require the use of freehand airbrush.

ANGLE OF REFLECTION

Depending upon the position of the eye in relation to the source of light and the object observed, a larger or smaller number of particles are reflected on the retina (Figure 3–2). The strongest reflections are made by beam 1 for eye C; beam 2 for eye A; beams 1 and 3 less intense for eye B; and beams 2 and 3 less intense for eye C. So, the only way the eye perceives an object, whether solid or not, is by analyzing the amount of light it reflects. A faceted solid shape (Figure 3–3) will have precise linear (R_1) separation between facets. A rounded solid (Figure 3–4) will have a smooth transition of intensities, and a mixed (faceted and rounded) solid will have a mixed treatment, usually S or R_{1-10} (Figure 3-5).

The angle at which light strikes the various planes of an object is of concern to the airbrush artist. In Figure 3–8, light hits a three-planed object with different degrees of intensity. Where light is striking most directly, the plane is rendered very lightly; where the light is less direct, the plane is darker. Remember, the degree of light is what describes the form of this simple geometric object.

SCATTERING

When light is scattered, the number of photons that reach the eye are reduced. Depending on the microscopic geometry of materials, the eye can detect a larger or smaller amount of photons. See the way light strikes various surfaces—smooth (glass), semismooth, and rough—in Figures 3–6a, b, c. Remember, airbrush is an excellent medium for rendering the sleek, polished look of a smooth surface.

Smooth surfaces, like mirrors and glass, reflect all light in the same direction; and the eye receives all particles without loss of intensity. The image obtained by the eye is, or almost is, a mirroring of the source of light or of its reflection. If the source is reflected, it would be rendered with a highlight, and would in most cases be rendered with a brush rather than airbrush. This highlight, or accent, can be observed in Figures 3–11 through 3–16, where the smooth surfaces—whether mirrored, cylindrical, or wavy—are described by the highlighting.

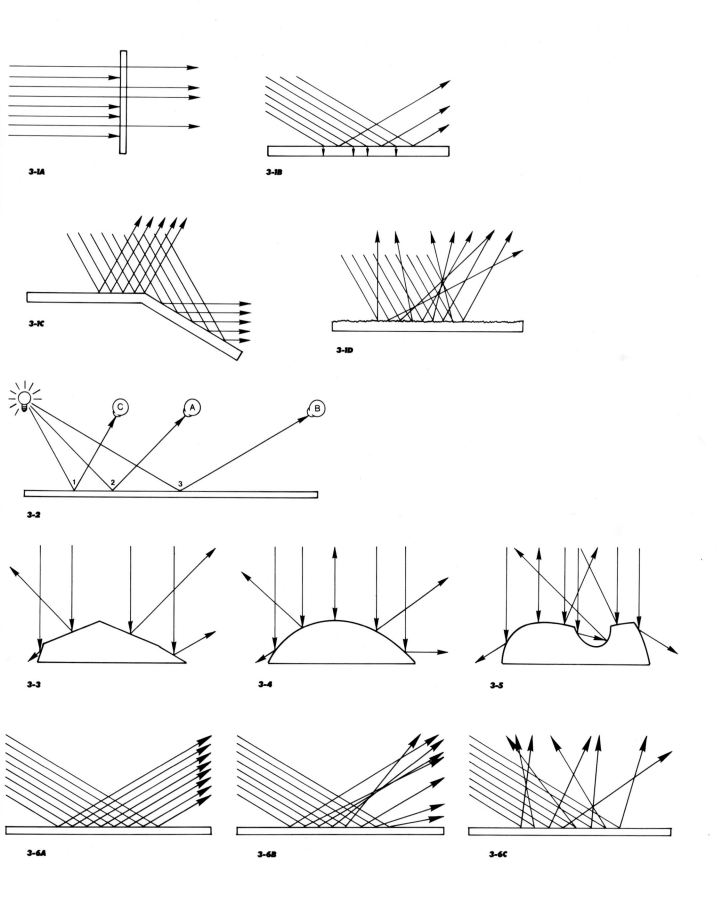

3-1A

3-1B

3-1C

3-1D

3-2

3-3

3-4

3-5

3-6A

3-6B

3-6C

3-7 **Filtration Effect: Gauze Screen**

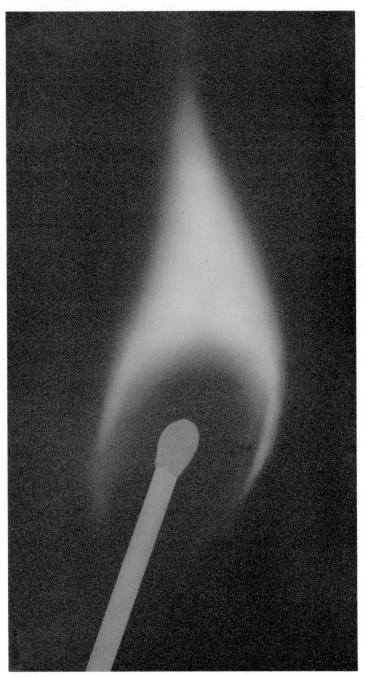

Support: 100Bk

Step 1: $\boxed{\text{F}}$ (O) 100W R_{10} D_{30}

Filtration Effect: Red Glass

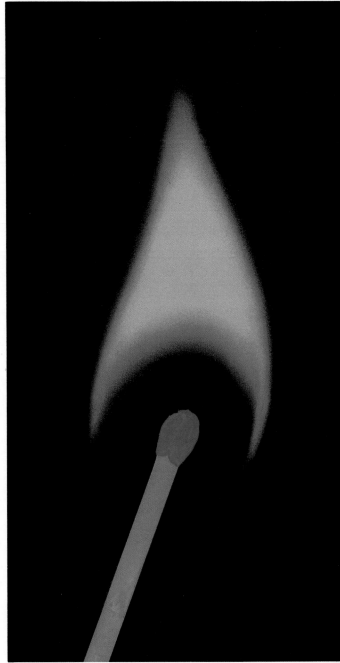

Support: 100Bk

Step 1: $\boxed{\text{F}}$ (T) 100Rd$_1$ R_{10} D_{30}

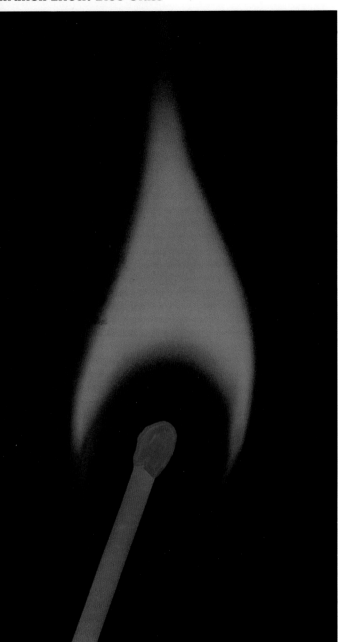

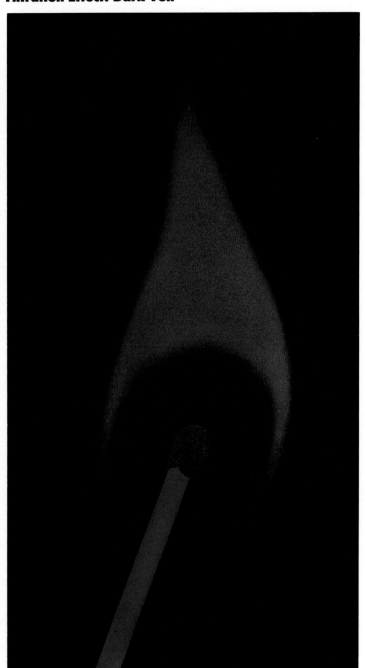

Support: 100Bk

Step 1: Ⓕ (T) 100Bl$_3$ R$_{10}$ D$_{30}$

Support: 100Bk

Step 1: Ⓕ (T) 100Bk R$_{10}$ D$_{30}$ or more

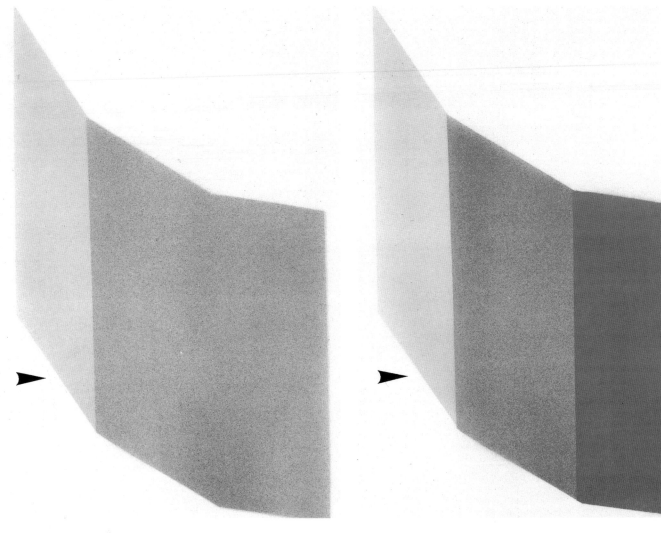

Step 3: Ⓜ or Ⓢ (T or O) 60W + 40Bk R$_8$ D$_{100}$

VARIANT 1:
Step 1: Ⓜ (T or O) 90W + 10Bk R$_{10}$ D$_{80}$ (uniform color)
Step 2: Ⓜ or Ⓢ (T or O) 60W + 40Bk R$_8$ D$_{80}$

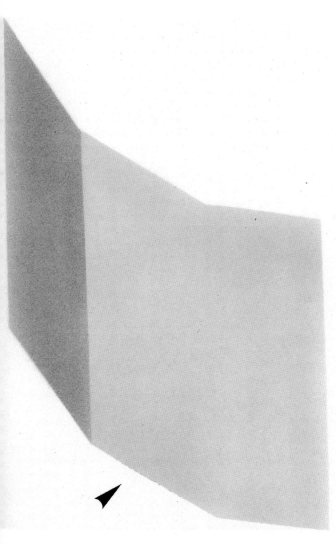

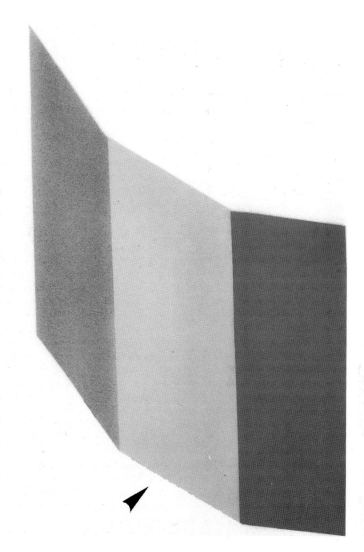

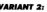

VARIANT 2:

Step 1: Ⓜ (T or O) 90W + 10Bk R_{10} D_{80} (uniform color)

Step 2: Ⓜ or Ⓢ (T or O) 60W + 40Bk R_{10} D_{40}

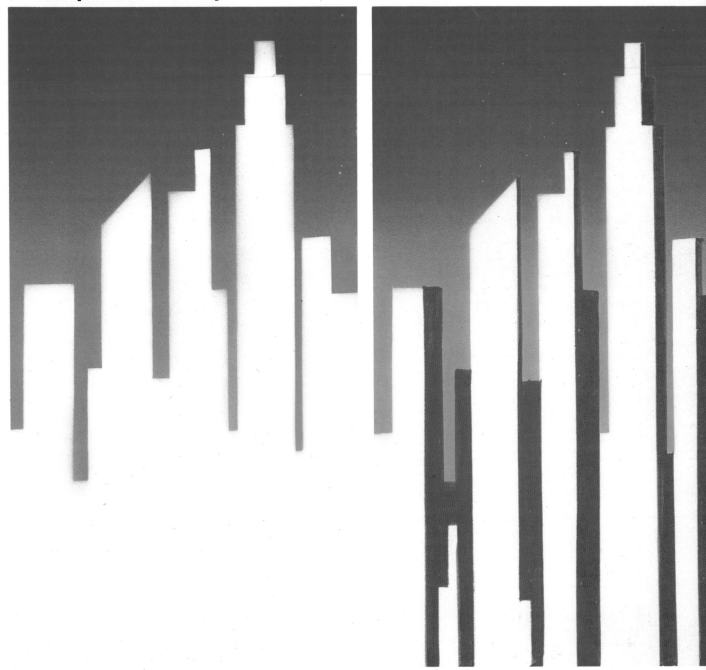

Support: 100W

Step 1: Ⓜ (O) 20W + 80Bl$_3$ R$_{10}$ D$_{100}$
Step 2: Ⓜ (O) 100Bl$_3$ R$_5$ D$_{100}$ ↓ D$_0$

Step 3: Ⓑ (O) 50W + 50Bk

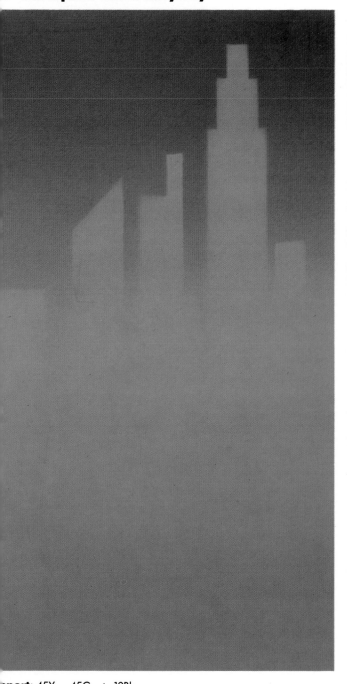

Support: $45Y_3$ $45G_1$ + 10Bk

Step 1: Ⓜ (O) $40Y_3$ + $40G_1$ + 20Bk R_{10} D_{100} ↓ D_{10}

Step 2: Ⓑ (O) 50W + $20Y_3$ + $20G_1$ + 10Bk
Step 3: Ⓕ (O) 95W + 5Bk R_5 D_{30}

Support: 100W

Step 1: Ⓜ (O or T) 90W + 10Bk R_{10} D_{80}
Step 2: Ⓜ or Ⓢ (O or T) 60W + 40Bk R_8 D_{80}

Step 3: Ⓜ or Ⓢ (O or T) 60W + 40Bk R_{10} $D_{10} \rightarrow D_0$(left panel)
Step 4: Ⓜ or Ⓢ (O or T) 60W + 40Bk R_3 $D_{90} \rightarrow D_0$(right panel)

Note: Eye compensation is the sharp value contrast found along the line separating the different planes of an object. This phenomenon seems to be caused by the eye's recording the light side of an object as lighter than it actually is while at the same time recording the adjacent plane as darker.

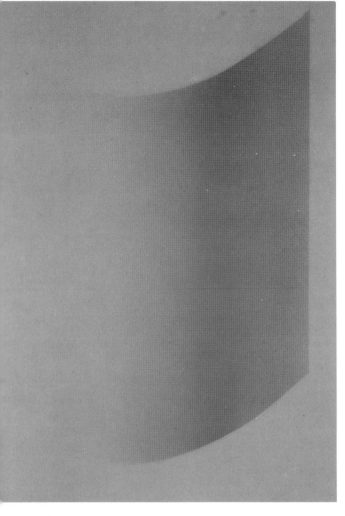

pport: 70W + 30Bk

ep 1: F within M (O) 50W + 50Bk R_5 $D_{60} \leftarrow D_0$

ep 2: F (O) 50W + 50Bk R_3 D_{100}(highlight)

Step 3: F (O) 100W R_5 $D_{30} \rightarrow D_0$

Step 4: F (O) 100W R_3 S(highlight)

Assignment

Render two adjacent (one blue and one red) dull plastic book spines as shown in the drawing. Because the surface is dull and the shape cylindrical, refer to Figure 3–14 for the correct procedure to follow. Remember that there will be no white brush highlights. In order to keep the two colors separate, work one after the other using different masks. However, if you choose to make the spines identical (the same size and shown from the same perspective), use only one mask for both.

Step 1: ⊞ R₄

Step 2: ⊞ R₃

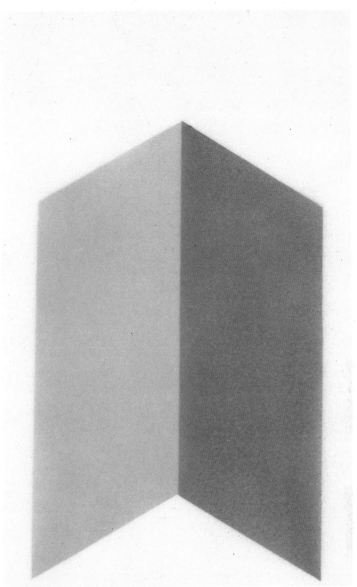

ep 3: F R₂

Step 4: M or S R₁

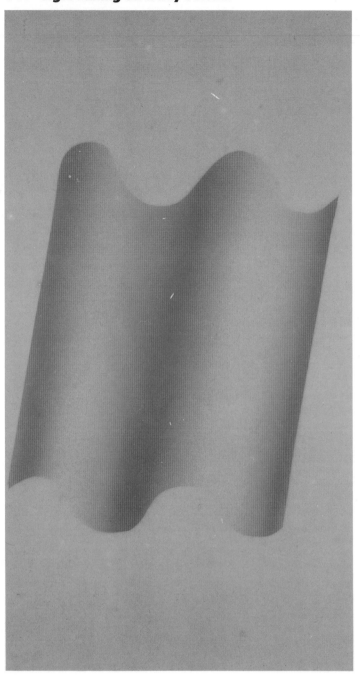 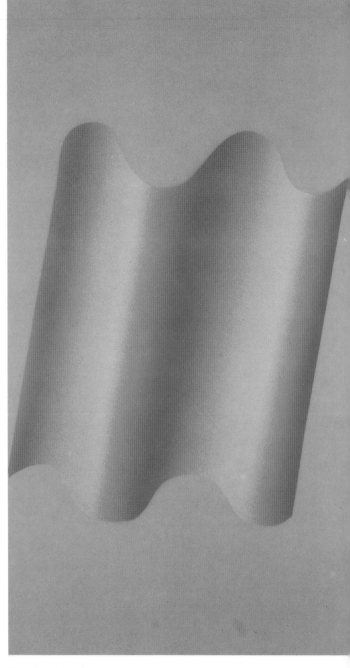

Support: 70W + 30Bk

WITHIN MASK

Step 1: \boxed{F} (O) 50W + 50Bk R_2 D_{10}
Step 2: \boxed{F} (O) 50W + 50Bk R_2 D_{100}

Step 3: \boxed{F} (O) 100W R_2 D_{10}
Step 4: \boxed{F} (O) 100W R_2 D_{100} or S

Light Falling on a Wavy and Creased Surface

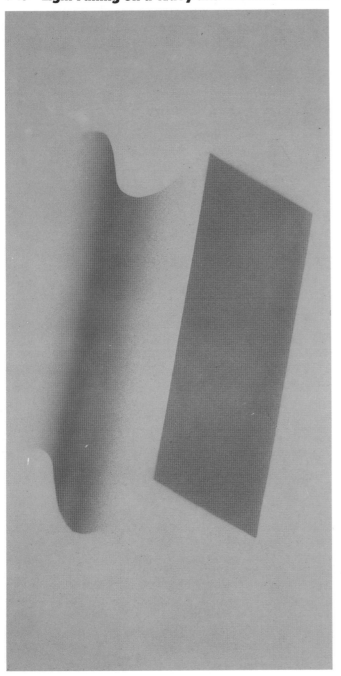 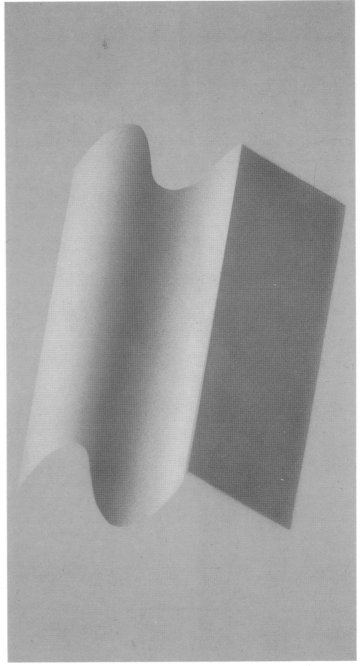

Support: 70W + 30Bk

WITHIN MASK

Step 1: ☐F (O) 50W + 50Bk R_2 D_{10}(left side)
Step 2: ☐F (O) 50W + 50Bk R_2 D_{100}(left side)
Step 3: ☐S (O) 50W + 50Bk R_4 D_{50}(right side)

Step 4: ☐F (O) 100W R_2 D_{10}
Step 5: ☐F (O) 100W R_2 S

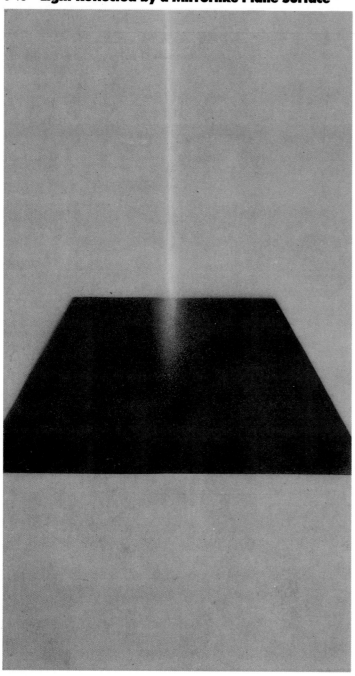

Support: 70W + 30Bk

Step 1: Ⓜ (O) 20W + 80Bk(uniform tone) remove mask

Step 2: Ⓕ (O) 90W + 10Bk R_2 D_{80}(beam only)

Step 3: Ⓕ (O) 100W R_3 D_{100}

Step 4: Ⓣ (O) 100W R_3 S

Note: In a mirror, the source of light is reflected as the image of the source, whether the source is the sun, a match, or a lightbulb. On a polished metal surface, the reflected light will be slightly blurred.

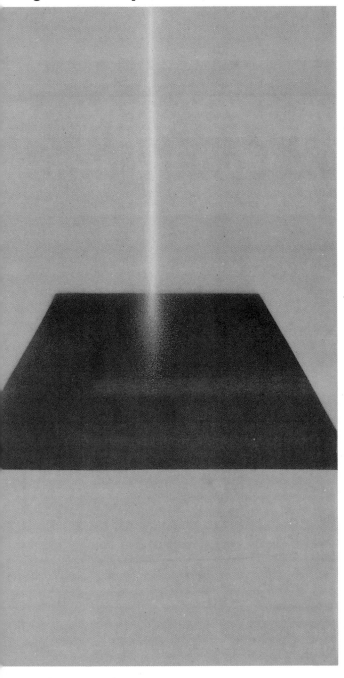

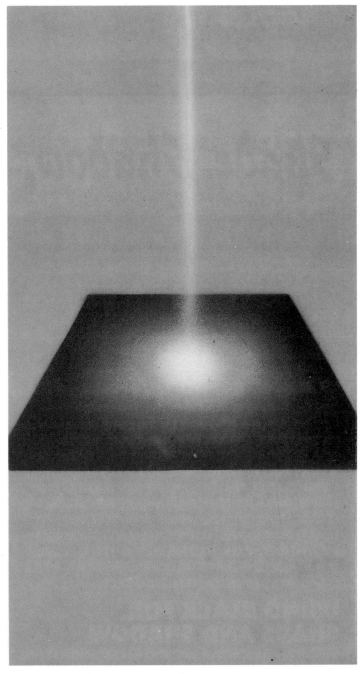

pport: 70W + 30Bk

IE AS 3-16, THEN:

Step 1: F (O) 80W + 20Bk R_4 D_{100}(center)
 (or 100W R_5 D_{50})
Step 2: F (O) 100W R_2 S(center) No T!

Chapter 4

Shade, Shadow, and Counterlight

When one or more sides of an object are out of reach of the light, the intensity of light there becomes zero (see Figure 4–1) and that side (or sides as the case may be) is shaded. When the object A bars the light particles from reaching object B, the partial or total surface of object B is in shadow. When an object C reflects particles coming from the light source back to objects A and B, these objects receive a reduced light intensity called *counterlight*. In fact, zero intensity of light (or complete shade) is possible only in a space without reflecting objects. The enormously various amounts of matter (including air molecules) on earth reflect and scatter light particles everywhere. Therefore a cube orbiting in outer space (Figures 4–3, 4–4) will look entirely different from a cube in terrestrial atmospheric conditions.

USING BLACK FOR SHADE AND SHADOW

Capturing counterlight is fundamental to airbrush art. And the tonal values available to the airbrush artist who has mastered the airbrush medium make it possible for him or her to avoid using 100 percent black. However, some illustrations, such as those shown in Figures 4–7, 4–9, and 4–10, call for black because it provides a dramatic accent for the adjacent color as well as defining form that is hidden by shadow.

MULTIPLICITY OF COUNTERLIGHTS

Let us suppose we have two identically colored objects (01 and 02), as shown in Figure 4–2. Sunlight comes from the left (arrow A) and, from our perspective, we perceive the lighted sides 1 and 2 of object 01 in two tones. The shaded side of 01 receives counterlight from the air molecules (arrow C); scattered reflections from the ground (arrow D); and another from object 02 (arrow B). Since object 02 is partially covered by the shadow of 01, it has its own shade, which is also "lightened" by sky (arrow H) and ground (arrow G) counterlights. If we image more than one object to the right of object 01 and one more additional source of light besides the sun, then the play of light, shade, shadow, and counterlight increases dramatically, giving the artist a great range of tones to play with.

Airbrush is particularly efficient in rendering the smooth blendings and gradual color transitions needed to convey atmospheric conditions. Figures 4–13 and 4–14 are examples of the three dimensionality, atmosphere, and drama that can be created with the use of counterlights, even with very simple objects. The airbrush is an excellent medium for capturing the subtleties of light play on various forms. You can create a sharp contrast by spraying a resolution of 1 using a mask or shield, or you can achieve great delicacy by simply controlling the density.

EYE COMPENSATION

An airbrush artist should be aware that in addition to the geometric factors that determine the variations of light intensity, shade, shadow, and counterlight, there is also a subjective element that determines form—the so-called eye compensation factor. Eye compensation comes into play whenever there are two adjacent surfaces (whether plane or curved, whether geometrically definable or not, whether belonging to the same solid or two), the eye enhances the contrast between them either by lightening the luminous edge or by darkening the darker one—or both—along the separation line. Examples of eye compensation can be found in Figures 3–12, 4–15, and 4–16.

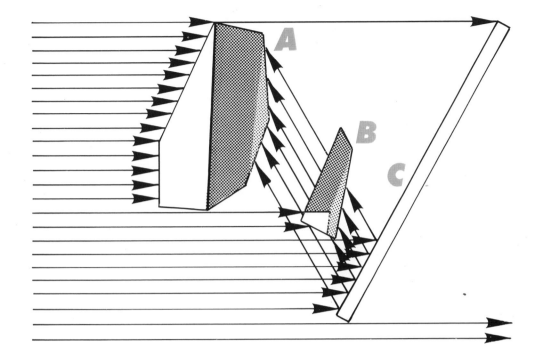

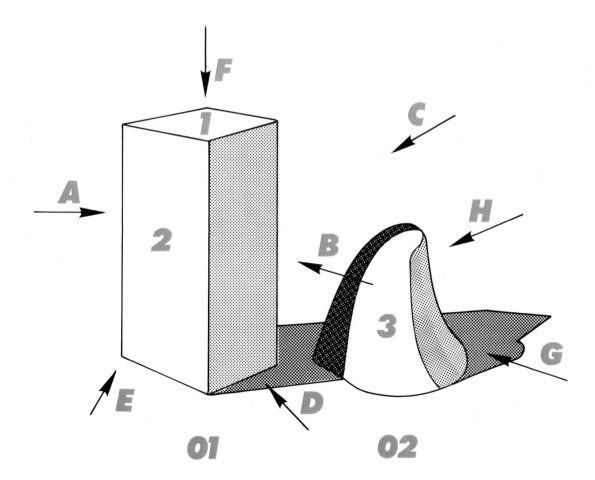

4-3 Remotely Spaced Cubes Floating in Outer Space

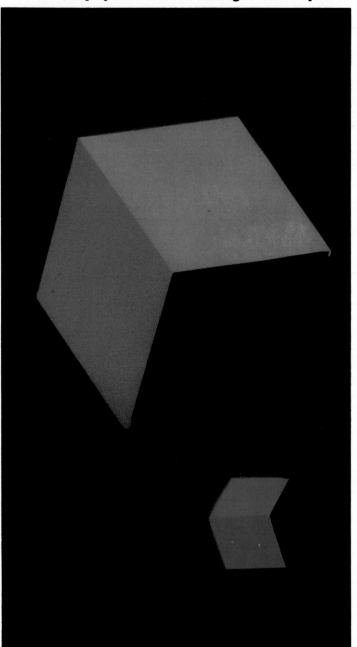

4-4 Closely Spaced Cubes Floating in Outer Space

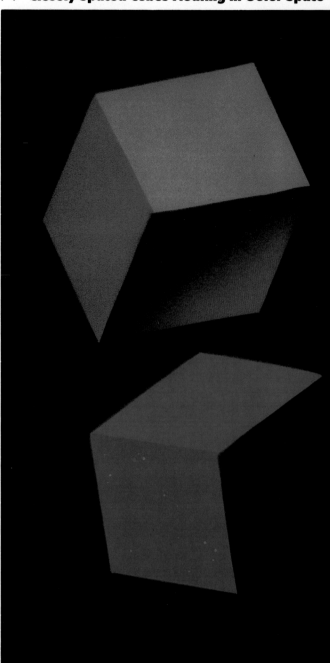

Support: 100Bk

Step 1: Ⓜ (O) 100Rd$_1$ R$_4$ D$_{100}$
Step 2: Ⓜ (O) 80Rd$_1$ + 20Bk R$_4$ D$_{100}$
Step 3: Ⓜ (O) 100Bl$_1$ R$_4$ D$_{100}$
Step 4: Ⓜ (O) 100Bl$_2$ R$_4$ D$_{100}$

Support: 100Bk

Step 1: Ⓜ (O) 100Rd$_1$ R$_4$ D$_{100}$
Step 2: Ⓜ (O) 80Rd$_1$ + 20Bk R$_4$ D$_{100}$
Step 3: Ⓜ (O) 50Rd$_1$ + 50Bl$_1$ R$_4$ D$_{100}$ ← D$_0$
Step 4: Ⓜ (O) 100Bl$_1$ R$_4$ D$_{100}$
Step 5: Ⓜ (O) 100Bl$_2$ R$_4$ D$_{100}$

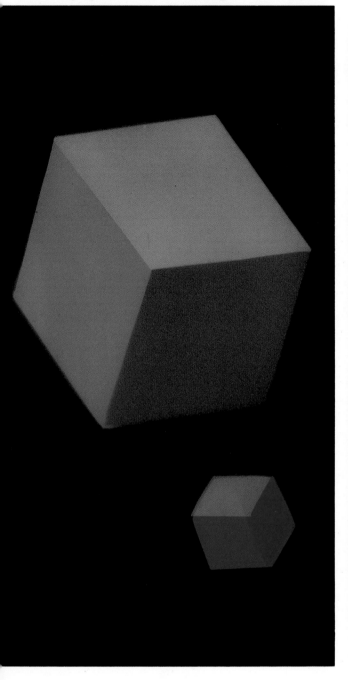

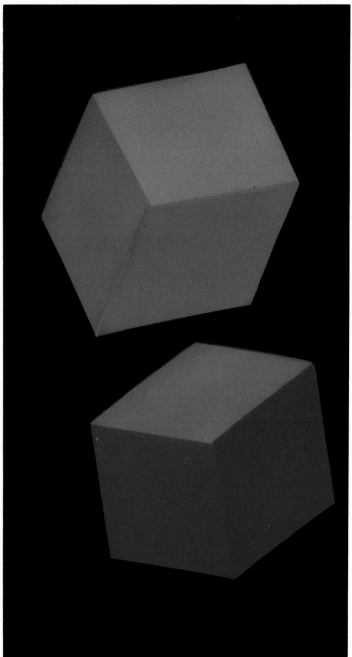

pport: 100Bk

p 1: Ⓜ (O) 50W + 50Rd$_1$ R$_4$ D$_{100}$
p 2: Ⓜ (O) 100W + 50Rd$_1$ R$_4$ D$_{100}$
p 3: Ⓜ (O) 80Rd$_1$ + 20Bk R$_4$ D$_{100}$
p 4: Ⓜ (O) 50Bk + 50Bl$_1$ R$_4$ D$_{100}$
p 5: Ⓜ (O) 100Bl$_1$ R$_4$ D$_{100}$
p 6: Ⓜ (O) 100Bl$_2$ R$_4$ D$_{100}$

Support: 100Bk

Step 1: Ⓜ (O) 50W + 50Rd$_1$ R$_4$ D$_{100}$
Step 2: Ⓜ (O) 100Rd$_1$ R$_4$ D$_{100}$
Step 3: Ⓜ (O) 80Rd$_1$ + 20Bl$_1$ R$_4$ D$_{100}$
Step 4: Ⓜ (O) 50Bl$_1$ + 50W R$_4$ D$_{100}$
Step 5: Ⓜ (O) 100Bl$_1$ R$_4$ D$_{100}$
Step 6: Ⓜ (O) 100Bl$_2$ R$_4$ D$_{100}$

Note: The difference between the intensities of the two reds and the two blues on outer space rendering is not determined by light and shadow but by the light reflecting at different angles.

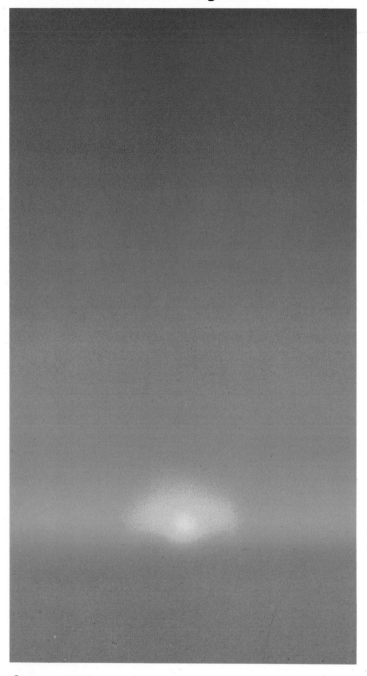 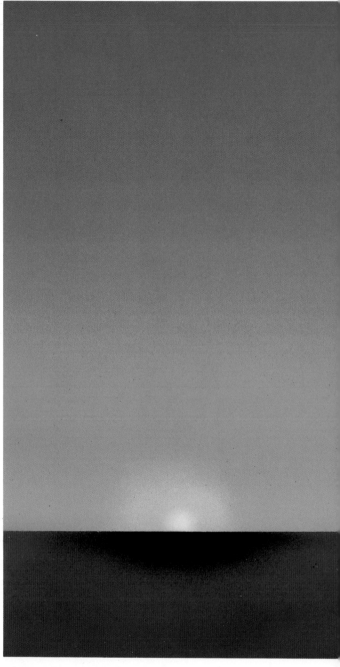

Support: 100Rd$_4$

Step 1: ☐F (O) 30Rd$_4$ + 50Bl$_4$ + 20W R$_7$ D$_{100}$ ↓ D$_0$
Step 2: ☐F (O) 100Co R$_5$ D$_{100}$ ↑ D$_0$
Step 3: ☐F (O) 100Y$_1$ R$_4$ D$_{100}$ ↑ D$_0$
Step 4: ☐F (O) 100W R$_2$ S

Step 5: ☐M (O) 100Br$_5$ R$_5$ D$_{100}$
Step 6: ☐M (O) 100Bk R$_1$ D$_{100}$ ↓ D$_0$

Folded Plane Surface without Counterlight

Folded Plane Surface with Counterlight

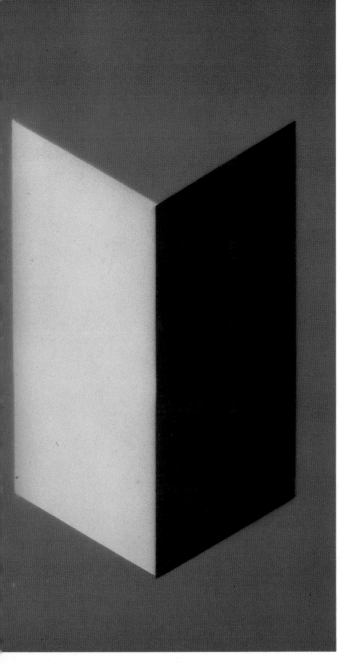

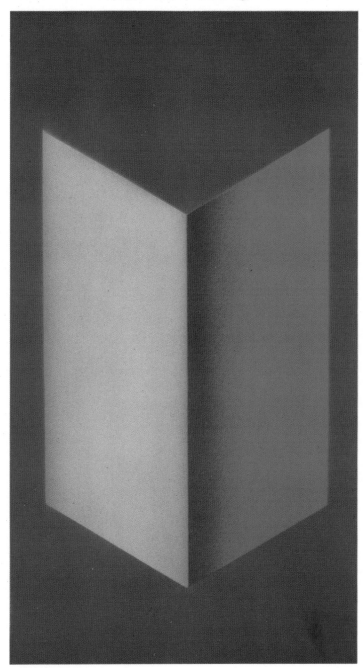

Support: 50Bk + 50W

Step 1: Ⓜ (O) 100W R_5 D_{100}
Step 2: Ⓜ (O) 20W + 80Bk R_5 D_{100}

Support: 50Bk + 50W

Step 1: Ⓜ (O) 100W R_5 D_{100}
Step 2: Ⓜ (O) $60G_2$ + 40W R_5 D_{100}
Step 3: Ⓜ (O) 30W + 70Bk R_3 $D_{100} \rightarrow D_0$

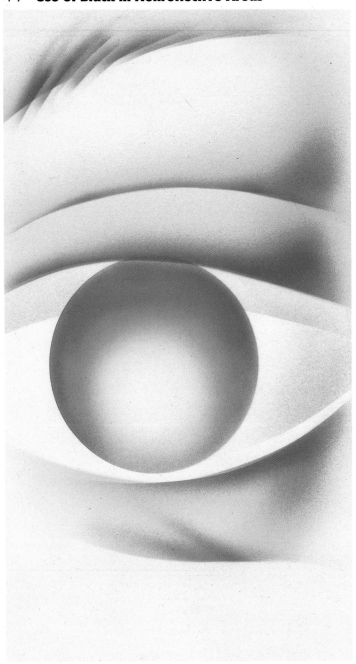
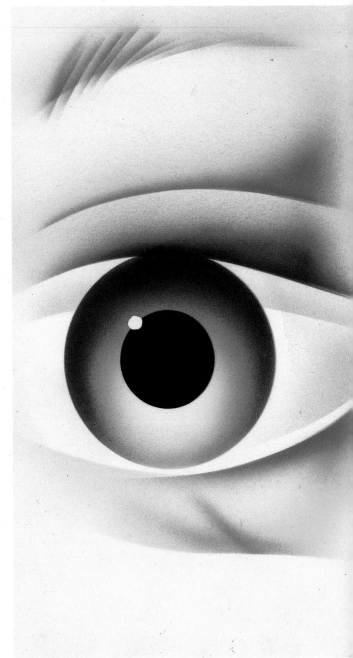

Support: 100W

Step 1: Ⓜ (O) 50W + 10Co + 40Y$_3$ R$_{2\text{-}3}$ D$_{10\text{-}100}$

Step 2: Ⓢ (O) 100Br$_5$ R$_{2\text{-}3}$ D$_{10\text{-}100}$

Step 3: Ⓣ (O) 100Bl$_4$ R$_2$ D$_{70\text{-}100}$

Step 4: Ⓕ + Ⓢ (O) 50Bk + 50Br$_5$ R$_{2\text{-}5}$ D$_{50\text{-}100}$

Step 5: Ⓕ + Ⓢ (O) 100Bk R$_{2\text{-}3}$ S

Step 6: Ⓑ (O) 100W(highlight)

pport: 100W

ep 1: Ⓢ (O) 50W + 10Co + 40Y₃ R₂₋₃ D₁₀₋₁₀₀

ep 2: Ⓢ (T) 100Rd₁ R₁₋₂ D₁₀₋₁₀₀

Step 3: Ⓢ (O) 100Br₅ R₂₋₃ D₁₀₋₁₀₀
Step 4: Ⓢ (O) 100Bk R₁₋₂ D₁₀₋₁₀₀

Curved Surface without Counterlight

Curved Surface with Counterlight

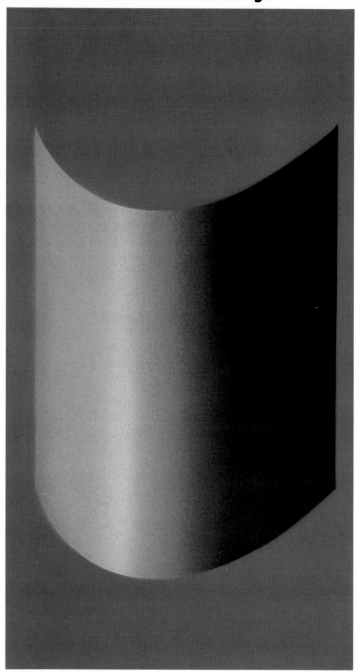

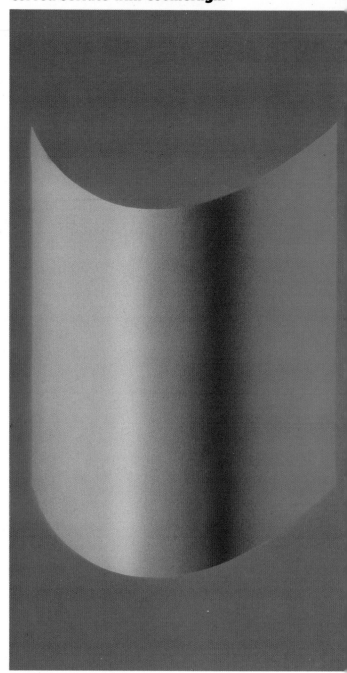

Support: 50Bk + 50W

Step 1: Ⓜ (O) 100W R_5 D_{100}
Step 2: Ⓕ within Ⓜ (O) 20W + 80Bk $R_{2\text{-}3}$ $D_0 \leftarrow D_{100}$

Support: 50Bk + 50W

Step 1: Ⓜ (O) 100W R_5 D_{100}
Step 2: Ⓕ (O) 60G_2 + 40W R_5 D_{100}
Step 3: Ⓕ (O) 20W + 80Bk R_3 $D_{100} \leftarrow D_0$

Support: $100G_1$

Step 1: Ⓜ (O) 100W R_5 D_{100}(entire object)
Step 2: Ⓜ (O) 40W + 60Bk R_5 D_{80} ↑ D_0(inside and outside object)
Step 3: Ⓜ (O) 40W + 30Bk + $30G_1$ R_2 D_{50}(inside object) and
$_0$ ↑ D_0(outside object)

Support: $100G_1$

Step 4: Ⓜ (O) 30Bk + $60G_1$ R_2 D_{100}(shadow on background)
Step 5: Ⓑ (O) 80W + 10Bk + $10G_1$(front edge of cylinder, not
rendered)

Note: The different intensities suggested by Step 3 result from the
unequally reflected amount of light hitting the inside and the outside
of the half cylinder. You should always be aware of these various
conditions and not treat the situations mechanically. Also, Step 2
indicates a brush technique for a flat surface which is used in order
to avoid the cutting of an additional mask. But if the rendering
requires various values and/or graduations, the airbrush must be
used.
 Step 2 and Step 3 can be reversed here in order to produce a
warmer or colder effect.

Black and White Analysis of Light Play

4-13 Simple Geometric Form

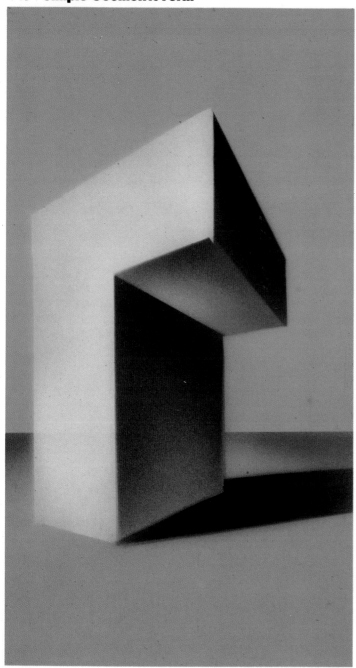

4-14 Curved Forms

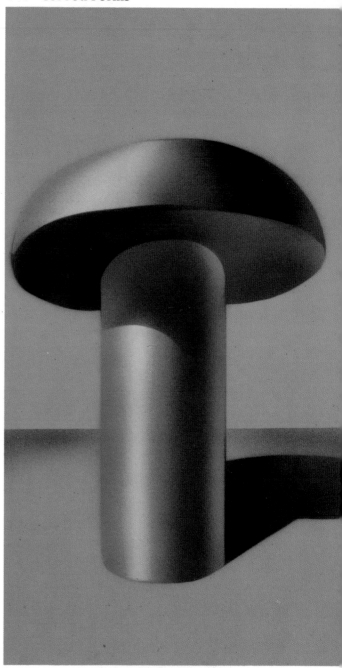

Support: 50W + 50BK

 Use Bk and W in varying proportions with Ⓜ and/or Ⓣ

Assignment

Render the objects shown in the drawing. Note that according to the arrows, there are two sources of light; Arrow *A* indicates sunlight, and arrow *B* indicates candlelight. As the exact location of these sources is not precisely defined, in relation to the objects, you must determine them for yourself, according to how you wish the whole composition to be rendered. The strong black lines indicate the rough shade and shadow limits. The rendering should be black and white with as many subtle grays as you can imagine.

 Begin by imagining that the objects are placed on a 50W + 50Bk background and that they are both white. Surface *a*, receiving light from source A at a very small angle, will be darker than surface *b*, which receives an almost perpendicular (90°) light

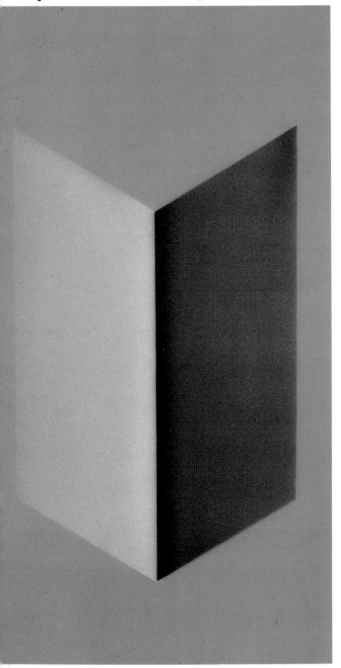

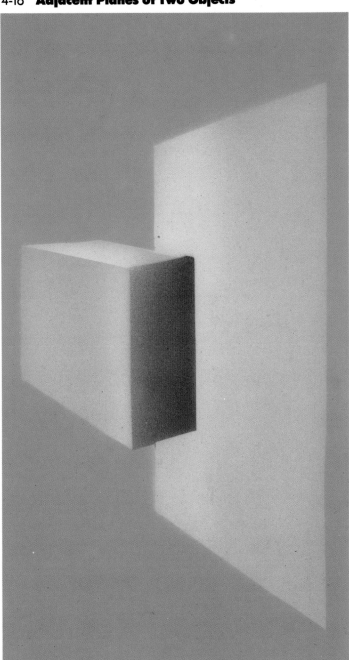

beam at its center. Surface *e* is darker than surface *c* (remember to enhance contrast at separation line!) and *f* is even darker, but not as dark as adjacent shadow *g*. The fusiform (or spindle shaped) object at the top receives light from source B on the *i* side, counterlight from *c* on the *j* side, and a faint counterlight on side *k* from the background.

You must determine the different gray intensities of these three surfaces in order to obtain a credible rendering. Masking strategy is also left to your choice, but a 100W support and only *one* (50W + 50Bk) transparent medium are suggested. Of course, the 50W + 50Bk requires more attention when leaving some surfaces entirely white, and more patience in repeating the sprays in order to obtain 100Bk or any other darker tone than the 50W + 50Bk tone.

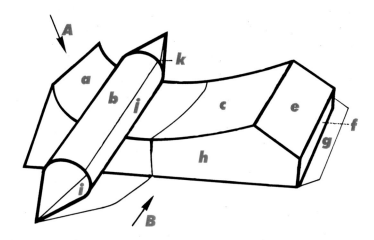

Chapter 5

Light in Color

Mastering the play of light on black and white geometrical objects is a basic theoretical requirement for the understanding of color airbrushing, particularly when considering the play of light on colored forms.

The illustrations in this section are not so much specific objects and should be considered more like abstractions or colored forms. Using form in this way provides an opportunity to combine realistic, objectively determined tones and hues even when the actual model is not available.

DEFINABLE AND NONDEFINABLE OBJECTS

The exercises in this section are divided into the two areas of drawing—the geometrically definable and the geometrically nondefinable. However, because nondefinable shapes are infinitely more complex, you should become proficient at theoretically reducing objects to their elementary, geometric shapes. One way to improve your skills is to try to imagine a similarity between the geometrically nondefinable form and its basic geometric equivalent.

In addition, it is good practice to make pencil studies of the light and shadow relationships of your subject before beginning an airbrush rendering. Throughout this book photographic references have been avoided in order to improve your ability to visualize in airbrush. By improving your ability to visualize and conceptualize in airbrush, you should be able to go beyond the static photographic look achieved by so many technically proficient airbrush artists.

Although many airbrush works are executed with a photographic exactness, I find this look often strips the airbrush medium of its full potential. More important, I

believe, is to try to reach for the airbrush's unique characteristics, which is often an ability to transform what's actually seen into an evocative image.

The aim of this book is to present those analytical steps that will build basic geometric structures so that you can use this conceptual visualization to create more complex, organic structures. Thus the renderings that are simple forms (Figures 5–1, 5–2, 5–3, 5–4, 5–5, 5–6, 5–7, 5–8) will help you in the long run to conceive of the more intricate organic forms (Figures 5–9, 5–10, 5–11). And in dealing with these more complex forms—like the rippling surfaces of a lake, the convolutions of human and animal shapes, or the rippling sands of the desert—you will find that you will need to rely less and less on the airbrush mask. In many cases (Figures 5–10 and 5–11), these organic shapes require the use of free airbrush and the airbrush shield.

WARM AND COOL COLOR CONTRASTS

Suppose that a black and white cylinder rests on a flat surface and is lit from the left by the sun, as in Figure 5–2. The shaded part will receive a reflection of sunlight from the atmospheric air molecules. Because the atmosphere absorbs all the other wavelengths of the solar spectrum except the blue one, the counterlight will be blue and therefore cooler than the warmer, yellow sunlight. Or, as in Figure 5–3, if the light of the moon strikes the left side of the cylinder, that side is warmer than the right side which will necessarily be cooler. From this observation of natural color variation, artists throughout history have often interpreted color values by exaggerating the effect of warm lights against cool counterlights, or vice versa.

Color Interpretation of 4-13

pport: 50W + 50Bl₄

UND

p 1: Ⓜ (O) 100G₂ R₄ D₁₀₀

DOW

p 1: Ⓜ (O) 50G₂ + 50Rd₅ R₂ D₁₀₀

ECT

p 1: Ⓜ (O) 30Y₃ + 30Co + 30Br₄ + 10W(uniform color)
p 2: Ⓜ (O) 25Y₃ + 30Co + 45Br₄(uniform shading)

Step 3: Ⓜ (O) 70R₅ + 15Y₃ + 15Co R₂ D₁₀₀ ↓ D₀(enhance)
Step 4: Ⓜ (O) 50W + 50G₁ R₁ D₁₀₀ ↑ D₀(ground counterlight)
Step 5: Ⓜ (O) 50W + 50Bl₃ R₁ D₁₀₀ ↑ D₀(sky counterlight)

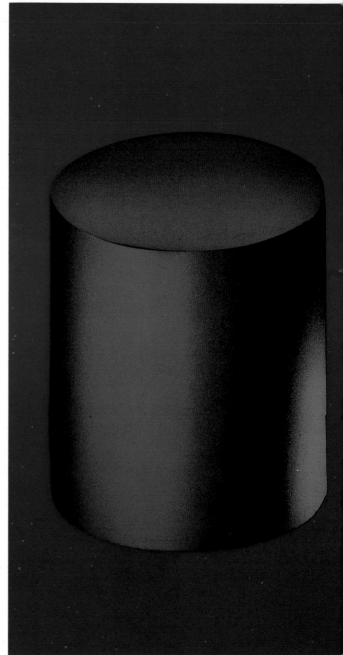

Support: 100Bl$_5$

Step 1-4: (same as Figure 5-4)
Step 5: Ⓜ (O) 30W + 40Co + 30Br$_2$ R$_2$ D$_{50}$ or D$_{100}$

Note: The addition of Br$_2$ used to indicate the color of candlelight is necessary to keep the firelit side more intense. The percentage of Br$_2$ will vary from 20 percent to 80 percent depending on the distance between the candle and the cylinder. The density may also vary depending on the intensity of the candlelight.

Effect of Moonlight, Fire, and Candlelight on Black Cylinder

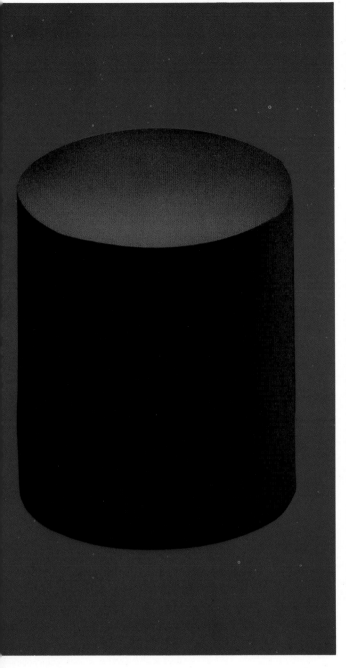

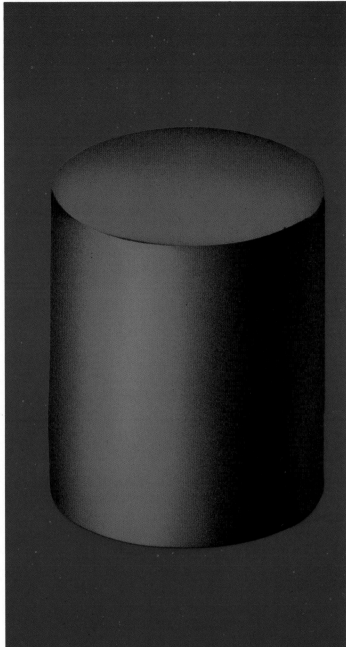

Step 4: Ⓜ (O) 100Rd$_1$ R$_3$ D$_0$ ← D$_{100}$ → D$_0$

port: 100Bl$_5$

p 1: Ⓜ (O) 100Bk R$_4$ D$_{100}$(uniform color)

p 2: Ⓜ (O) 50Bk + 25W + 25Bl$_1$ R$_2$ D$_{100}$ ↑ D$_{80}$(top)

p 3: Ⓜ (O) 50Bk + 25W + 25Bl$_1$ R$_2$ D$_0$ → D$_{30}$(side)

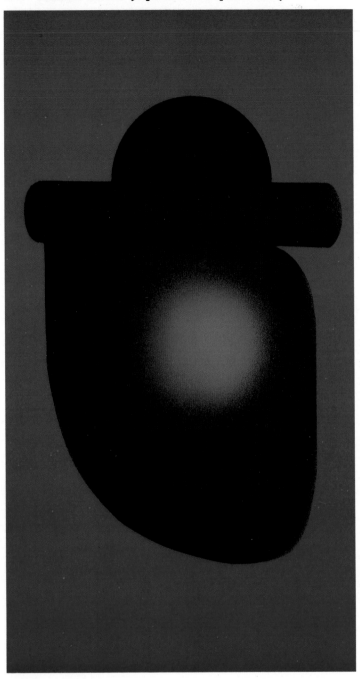 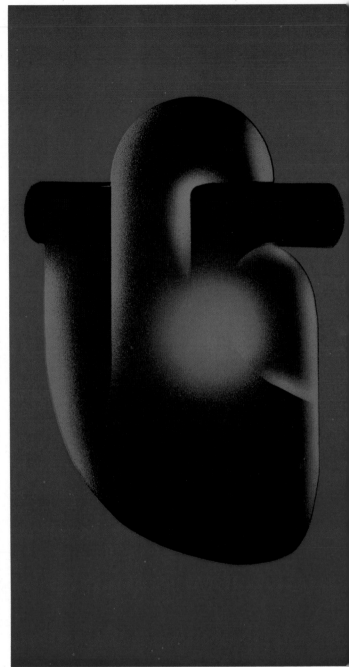

Support: 90Bl$_2$ + 40W

Step 1: Ⓜ (O) 100Rd$_5$ R$_4$ D$_{100}$
Step 2: Ⓕ (O) 100Rd$_1$ S(red area of pain)

LOW INTENSITY WHITE LIGHT
Step 1: Ⓢ (O) 50W + 50Rd$_3$ R$_{1-2}$ D$_{80}$ → D$_0$

GREEN LIGHT FROM RIGHT
Step 1: Ⓢ + Ⓜ (O) 100G$_1$ R$_{1-2}$ D$_0$ → S

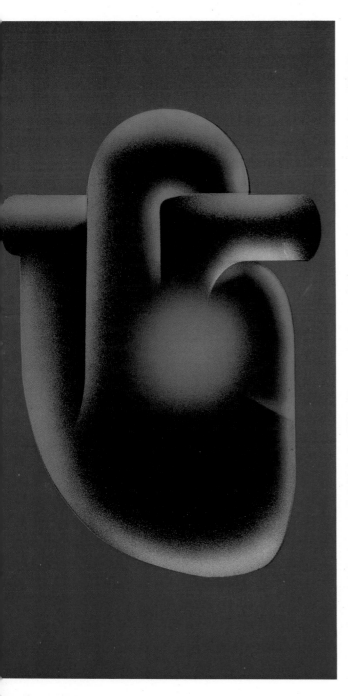

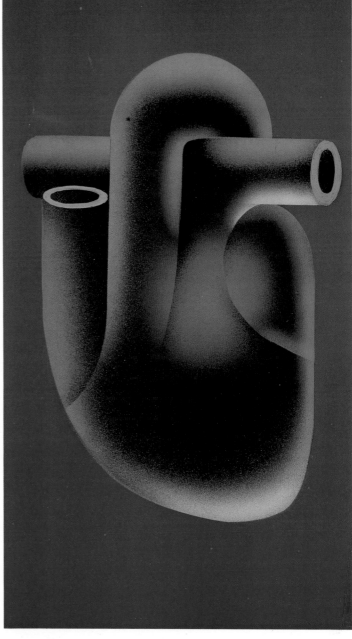

E LIGHT FROM ABOVE
ep 1: \boxed{S} + \boxed{M} (O) $70Bl_3$ + 30W R_{1-2} $D_0 \rightarrow S$

LOW LIGHT FROM BELOW
ep 1: \boxed{S} + \boxed{M} (O) $90Y_1$ + 10W R_{1-2} $D_0 \rightarrow S$

DARK ACCENTS
Step 1: \boxed{S} (O) 100Bk (or $100Rd_5$) R_{1-2} D_{30}

EDGE FACING BLUE LIGHT
Step 1: \boxed{B} (O) $80Bl_3$ + 20W

EDGE FACING GREEN LIGHT
Step 1: \boxed{B} (O) $90G_1$ + 10W

Color Interpretation of 4-14

First Shading

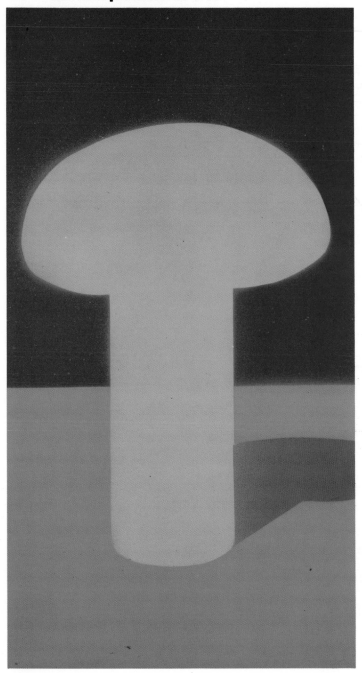

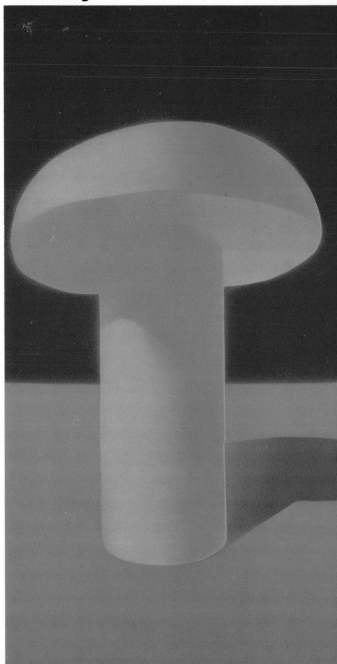

Support: 100Bl₁

GROUND
Step 1: Ⓜ (O) $80G_2$ + 20W R_4 D_{100}

SHADOW
Step 1: Ⓜ (O) $80G_2$ + $20G_4$ R_2 D_{60} ← D_{100}

OBJECT
Step 1: Ⓜ (O) 50W + $25Y_3$ + $25Br_1$ R_4 D_{100}(uniform color)

Step 1: Ⓜ (O) $100Br_3$ R_2 $D_{10\text{-}100}$
(use Ⓢ for curve shadow on stem)

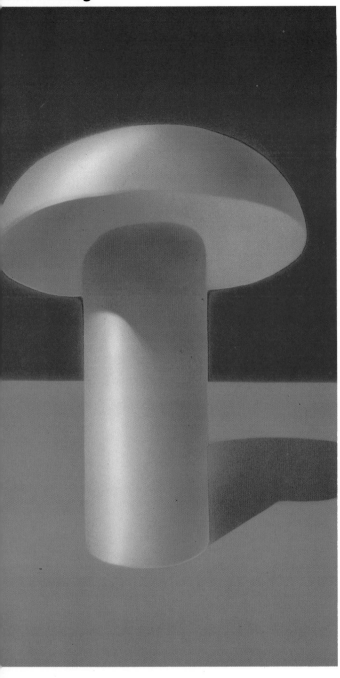
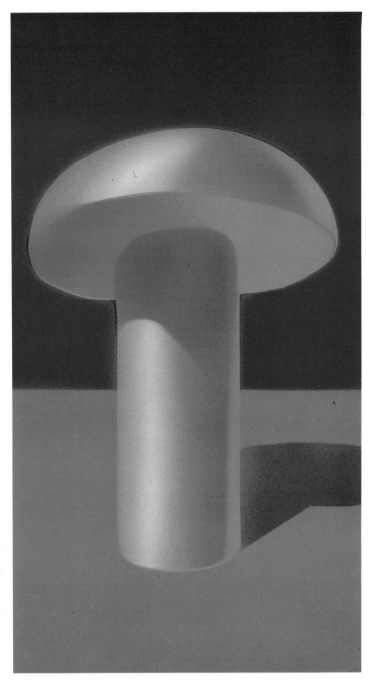

ep 1: Ⓜ (O) 100Br$_4$ R$_2$ D$_{0\text{-}100}$
ep 2: Light: Ⓜ (O) 100W R$_{1,2}$ D$_{30}$ → S

SKY COUNTERLIGHT ON MUSHROOM CAP
Step 1: Ⓜ (O) 20BK + 20Bl$_1$ + 60W R$_2$ D$_0$ ← D$_{100}$

GROUND COUNTERLIGHTS
Step 1: Ⓜ (O) 30Bk + 10W + 60G$_2$ R$_2$ D$_{100}$ (stem)
Step 2: Ⓜ (O) 30Bk + 10W + 60G$_2$ R$_2$ D$_{60}$ (under cap)

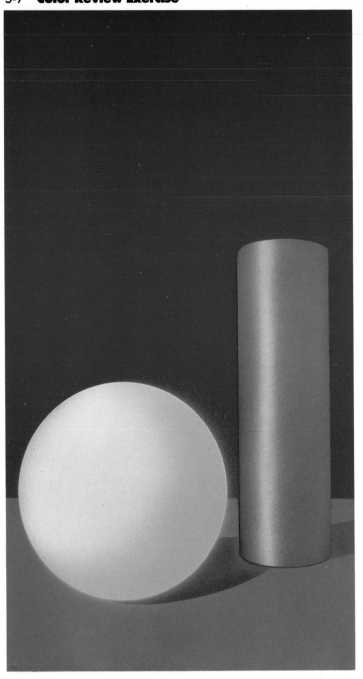

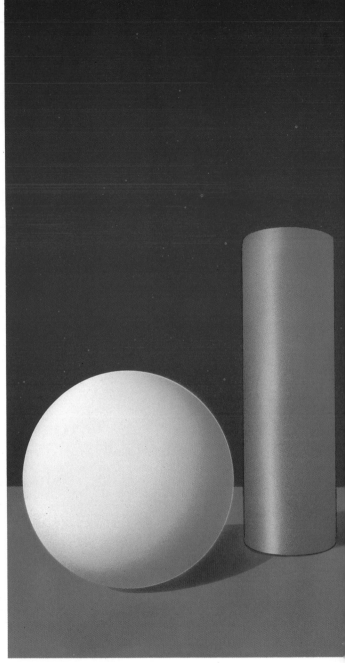

Support: $100Bl_5$

GROUND
Step 1: Ⓜ (O) $60W$ + $40Bl_4$　R_4　D_{100}

SHADOW
Step 1: Ⓜ (O) $50Bk$ + $50Bl_4$　R_3　D_{50}(on ground)

CYLINDER
Step 1: Ⓜ (O) $100Rd_1$　R_4　D_{100}

SPHERE AND LIGHT ON CYLINDER
Step 1: Ⓣ + Ⓜ (O) $100W$　R_4　D_{100}

FIRST SHADING ON SPHERE
Step 1: Ⓣ (O) $80W$ + $20Br_5$　R_2　$D_0 \leftarrow D_{100}$

FIRST SHADING ON CYLINDER
Step 1: Ⓜ (O) $100Br_2$　R_2　$D_0 \leftarrow D_{80}$

SECOND SHADING ON SPHERE
Step 1: Ⓣ (O) $50W$ + $50Br_5$　$R_{1,2}$　$D_0 \leftarrow D_{100}$

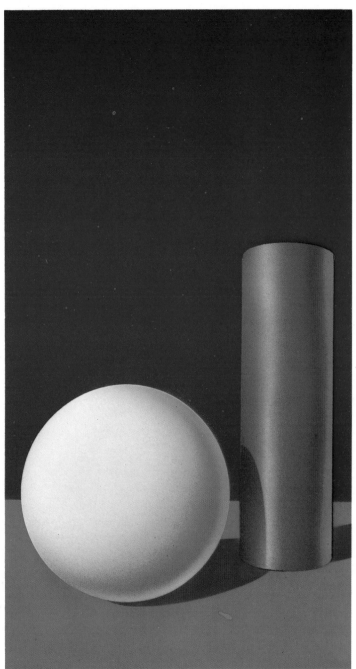

OND SHADING ON CYLINDER

ep 1: Ⓜ (O) 80Rd$_5$ + 20Rd$_1$ R$_2$ D$_0$ ← D$_{100}$

HERE SHADOW ON CYLINDER

ep 1: Ⓣ (O) 100Rd$_5$ R$_2$ D$_{100}$ ↓ D$_{30}$

COUNTERLIGHT

Step 1: Ⓣ (O) 80W + 20Bl$_3$ R$_1$ D$_{80}$(from ground to sphere)
Step 2: Ⓣ (O) 70W + 30Rd$_1$ R$_1$ D$_{100}$(from cylinder to sphere)
Step 3: Ⓜ + Ⓣ (O) 60W + 40Bl$_1$ R$_1$ D$_{100}$(from sky to sphere and
cylinder)

Support: Bl_2

SKY
Step 1: 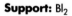 (O) $50Bl_1$ + $50W$ R_4 D_{100} ↑ D_0
Step 2: F (O) $10Bl_3$ + $90W$ R_2 D_{100} ↑ D_0

GROUND
Step 1: M (O) $50W$ + $50Y_3$ R_4 D_{100}
Step 2: M (O) $50Y_3$ + $50Rd_5$ R_3 D_{100} ↓ D_0
Step 3: M (O) $100Rd_5$ R_3 D_{100} ↓ D_{50}(shadow)

PYRAMID COLOR
Step 1: M (O) $50Bk$ + $50W$ R_3 D_{100}

PRISM COLOR
Step 1: M (O) $70Bl_5$ + $30W$ R_3 D_{100}

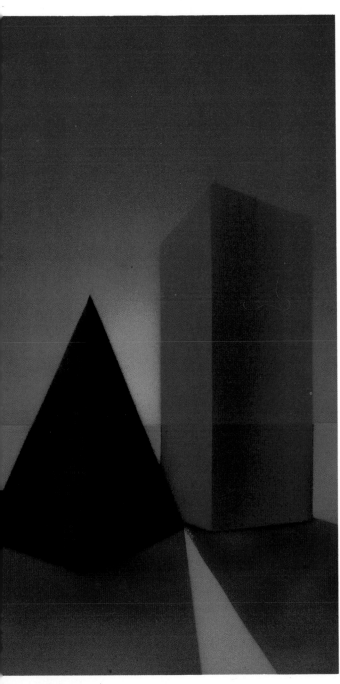

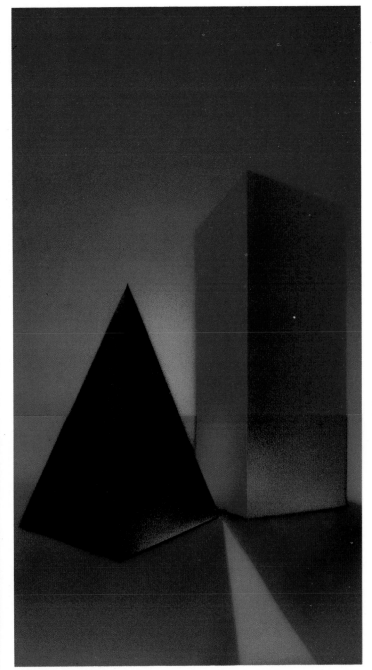

COND PYRAMID COLOR
ep 1: 100Bk R_2 D_{100}

COND PRISM COLOR
ep 1: 100Bl$_5$ R_2 $D_{100} \rightarrow D_{60}$

GROUND COUNTERLIGHT
Step 1: Ⓜ (O) 50Y$_3$ + 25Bk + 25W R_2 D_{80} ↑ D_0

PYRAMID COUNTERLIGHT ON PRISM
Step 1: Ⓜ (O) 30Y$_3$ + 20Bk + 30W + 20Bl$_1$ R_2 $D_{80} \rightarrow D_0$

Wavy Form Lighted by Sunlight and Counterlight

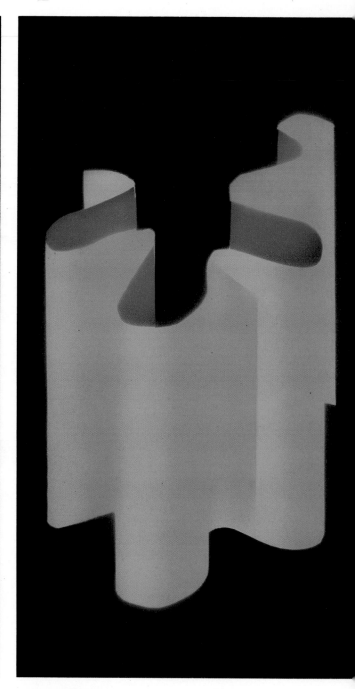

Support: 100Bk

RED UNDERSIDE
Step 1: Ⓜ (O) 100Rd$_1$ R$_3$ D$_{100}$

EXTERIOR OF FORM
Step 1: Ⓜ (O) 90W + 5Y$_1$ + 5Br$_1$ R$_3$ D$_{100}$

FIRST SHADING ON EXTERIOR
Step 1: Ⓜ + Ⓢ (O) 40W + 30Y$_1$ + 30Br$_1$ R$_2$ D$_{20}$ ← D$_{100}$

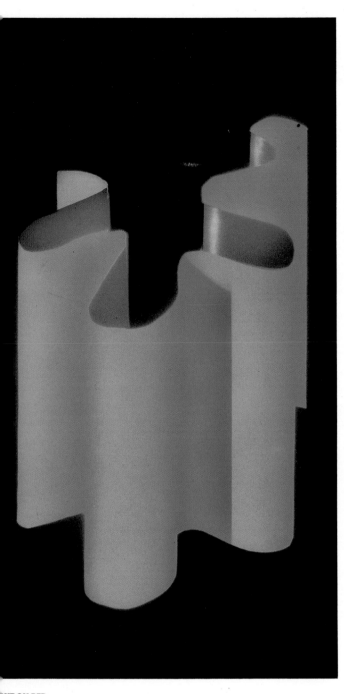

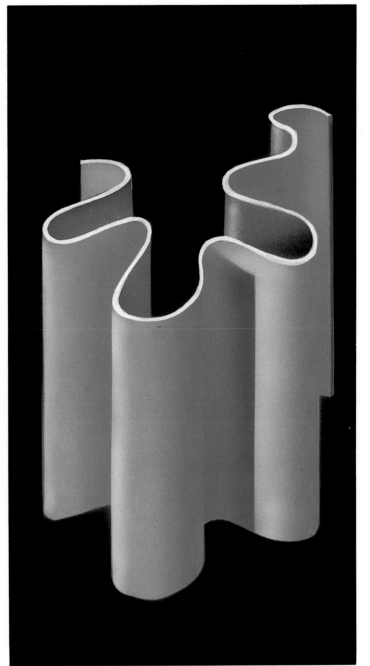

LIGHT ON RED
Step 1: Ⓜ (O) 60Rd$_1$ + 40W R$_2$ D$_{80}$

SECOND SHADING ON EXTERIOR AND SHADOW
Step 1: Ⓜ + Ⓢ (O) 100Br$_3$ R$_2$ D$_{80}$ ← D$_{100}$

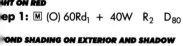

LIGHT ON EXTERIOR
Step 1: Ⓕ + Ⓢ within Ⓜ (O) 100W R$_{1\text{-}2}$ D$_{100}$ → D$_0$

COUNTERLIGHT
Step 1: Ⓕ + Ⓢ within Ⓜ (O) 80Bl$_4$ + 10Bk + 10W R$_{1\text{-}2}$
D$_{100}$ → D$_0$
Step 2: Ⓑ (O) Bl$_4$ + 10Bk + 10W(uniform edge at right)

TOP
Step 1: Ⓑ (O) 100W(uniform, wavy)

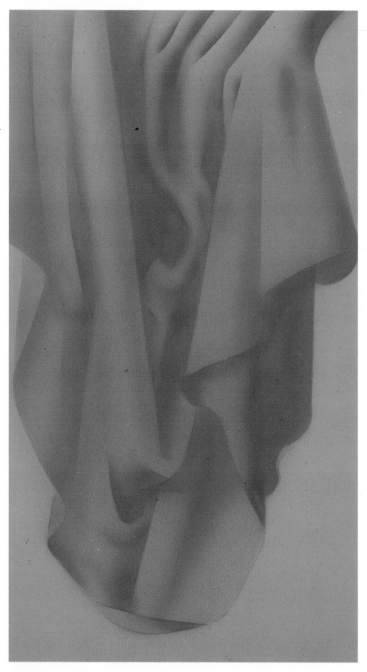

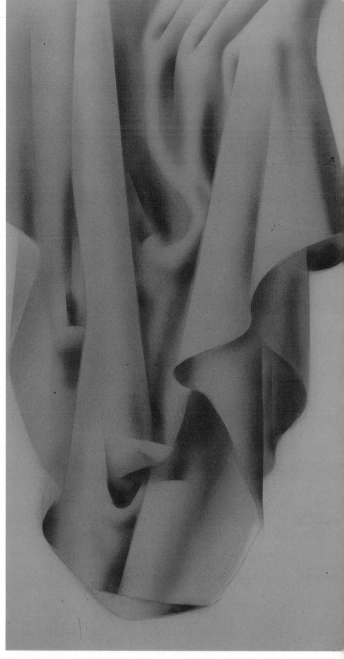

Support: $40G_1$ + $10Y_1$ + $10W$ $40G_2$

FIRST LAYER
Step 1: Ⓢ + Ⓕ (O) $10Bk$ + $25G_3$ + $65W$ R_{1-4} D_{0-100}

SECOND LAYER
Step 1: Ⓢ + Ⓕ (O) $20Bk$ + $25G_3$ + $55W$ R_{1-4} D_{0-100}

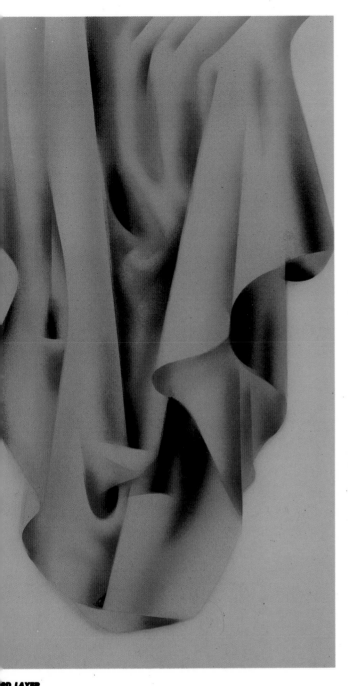

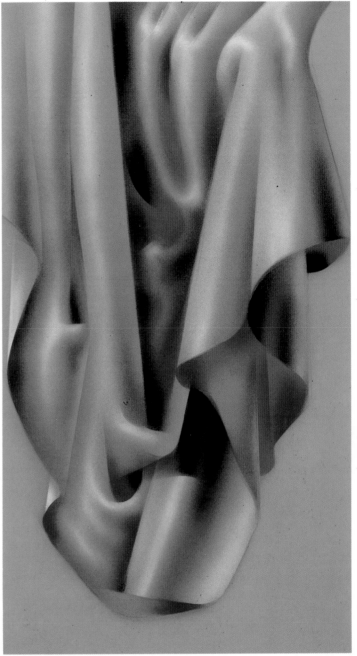

RD LAYER

ep 1: Ⓢ + Ⓕ + Ⓑ (O) 90Bk + 10G$_3$ R$_{1-4}$ D$_{0-100}$

te: Ⓑ is necessary at the deepest and darkest points in order to avoid unnecessary masking.

COUNTERLIGHT

Step 1: Ⓢ + Ⓕ (O) 60W + 40G$_3$ R$_{1-4}$ D$_{0-100}$

LIGHT

Step 1: Ⓢ + Ⓕ (O) 100W R$_{1-2}$ D$_{1-100}$

Note: If general color harmony needs alteration (for example, more blue tone) introduce before "light" a Ⓕ (T) 100Bl$_3$ R$_{10}$ D$_{20}$.

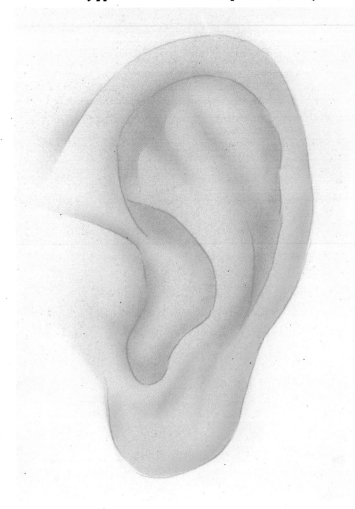

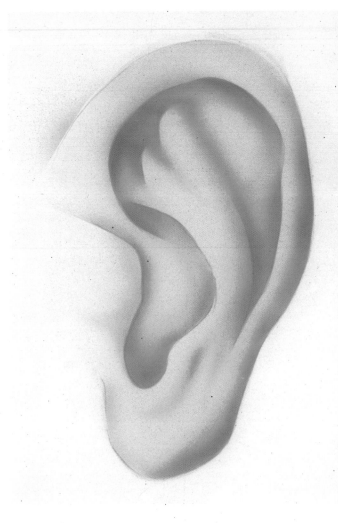

Support: 100W

Step 1: Ⓜ or Ⓢ (O) 80W + 10Co + 10Y$_3$ R$_{10}$ D$_{40\text{-}50}$(uniform color)

Step 2: Ⓢ (O) same color R$_{1\text{-}2\text{-}3}$ D$_{100\text{-}0}$(details)

FIRST SHADING

Step 1: Ⓢ (O) 60W + 10Co + 10Y$_3$ + 20Br$_5$ R$_{1\text{-}2}$ D$_{0\text{-}100}$

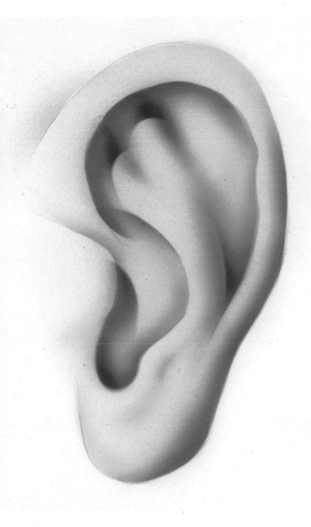

OND SHADING
ep 1: Ⓢ (O) 80Br$_5$ + 20W R$_{1-2}$ D$_{0-100}$

RD SHADING AND SHADOW
ep 1: Ⓢ (O) 80Br$_5$ + 20Rd$_5$ R$_{1-2}$ D$_{0-100}$

COUNTERLIGHT
Step 1: Ⓢ (O) 50G$_1$ + 40W + 10Bk R$_{1-2}$ D$_{0-100}$

LIGHT
Step 1: Ⓢ (O) 100W R$_{1-2}$ D$_{0-100}$

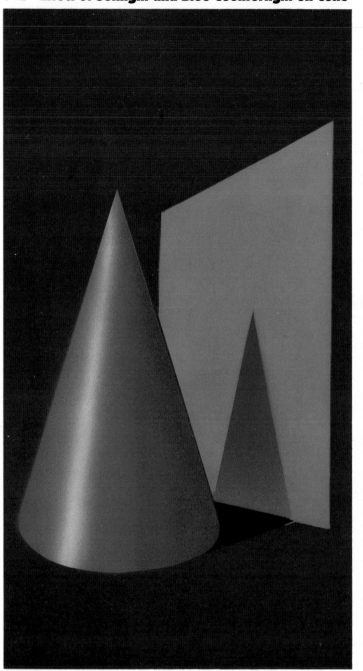

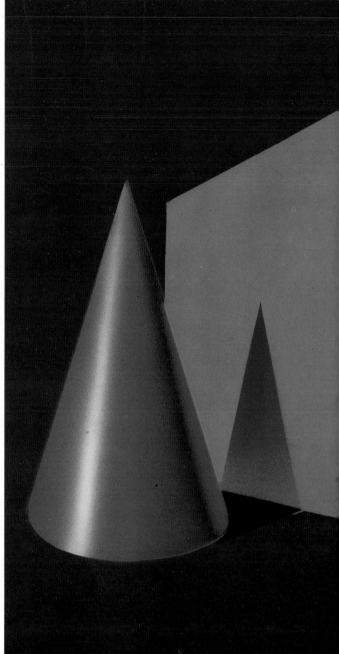

Support: 40Bk + 60Rd$_1$

CONE
Step 1: Ⓜ (O) 100Rd$_4$ R$_5$ D$_{100}$(uniform color)
Step 2: Ⓜ (O) Rd$_5$ R$_2$ D$_0$ → D$_{100}$(shade)
Step 3: Ⓜ (O) 100W R$_2$ D$_{100}$(sunlight)

SCREEN
Step 1: Ⓜ (O) 50W + 50Bl$_3$ R$_5$ D$_{100}$(uniform color)

SHADOW
Step 1: Ⓜ (O) 100Bk R$_3$ D$_{80}$(on ground)
Step 2: Ⓜ (O) 100Bl$_5$ R$_3$ D$_{100}$ ↓ D$_{30}$(on screen)

COUNTERLIGHT
Step 1: Ⓜ (O) 20Bk + 20W + 60Bl$_3$ R$_2$ D$_0$ ← D$_{100}$

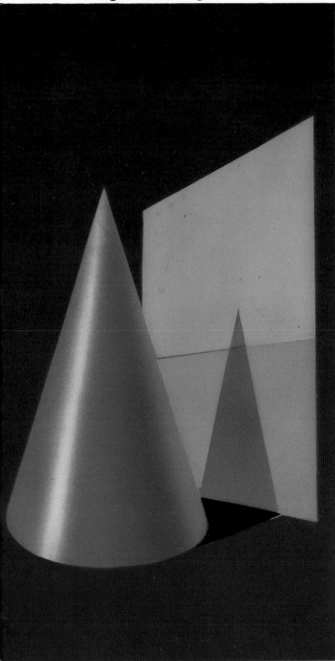

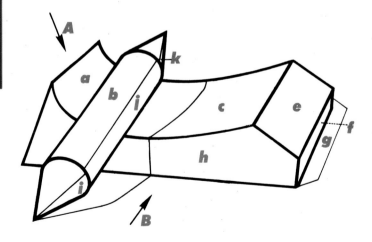

Assignment

Render in color the same assemblage of objects from the assignment in chapter 4, but this time use three distinctive basic colors, one for the background, one for the base, and another for the fusiform shape. The actual study of details remains the same, but the problem of color grows considerably. For instance:

1. The shadow of the fusiform falling on *c*, on *h*, and on the ground necessitates three various tones and hues, each being influenced by the color of the respective surfaces. Whereas shadows falling on the ground and on *c* will be simply darker, the shadow on *h* will certainly be darker too, but influenced by light B which alters not only that portion of the shadow but the area *h* in its entirety. Working with an opaque medium requires preparation of each color separately. Working with a transparent medium means you can spray color on already existing hues—a simpler method, but not always as rich in values as the ones obtained with opaques.

2. Shadow *g*, unlike the deep corner of the left-hand shadow on the ground discussed above, will be slightly lighter—perhaps a little colder too, if we take into consideration the existence of a sky counterlight.

3. Shades *i*, *j*, and *k* are continuous; however, each one receives a totally different counterlight that subtly enriches the compositional harmony.

To complete the assignment use the following strategy: First, paint the background. Next, spray the shadows on the ground. For this you should already have made a mental composition of the colors, or even better, a sketch to guide you. Now, spray the pedestal in all its details, then the shadow of the fusiform on it, and, as a final step, the fusiform itself.

In airbrush it is always a good idea to work gradually from the background and more distant objects toward foreground objects. In this example, the counterlights are related (*i* with *h* and *j* with *f*); and they should be worked at the very end, before the final white touches are sprayed on the lighted sides. Remember, no matter how careful you are, any color that is not white will spray a light tint on top of the clean white, thus necessitating a touch-up for any white highlights.

pport: 40Bk + 60Rd$_1$ (same as 5-12 except for screen and *n*terlight)

EEN
ep 1: Ⓜ (O) 100Y R$_5$ D$_{100}$
ep 2: Ⓜ (O) 100Co R$_5$ D$_{100}$

NTERLIGHT
ep 1: Ⓜ (O) 80Y + 20Br$_5$ R$_2$ D$_{100}$(blend with Step 2)
ep 2: Ⓜ (O) 100Co R$_2$ D$_{60}$

Part Two

Objects

Chapter 6

The Form and Geometry of Objects

In philosophy and physics, definitions of matter abound, but for the purposes of this book, matter is defined as *anything* that can produce or reflect light as perceived by the eye. Light itself, as established in Part I, is a form of matter, because it comprises particles and waves. However, even this broad definition of matter does not cover the entire inventory of artistic concepts, visions, and imagery available to the conceptually minded airbrush artist. Submicroscopic particles, objects in outer space, scientific theories—all never actually seen before—can excite the artistic imagination and result in images usually thought of as an artist's interpretation or as an artist's conception. Thus, renderings showing the structure of the atom, or the representation of a DNA chain, or the gravitational pull between two galaxies are all examples of artistic concepts.

But for now, let us return to the basics, to the elementary geometry of matter. As an airbrush artist you will have to solve many complex problems. You will be rendering intersecting solids and geometrically nondefinable ones. You will have to depict an accurate representation of a solid's structural appearance (wood, stone, etc.). You will also need to create atmosphere, which can change a solid's color entirely and even alter the clarity of its outlines.

The airbrush artist must also be able to show how adjacent objects produce various effects and how to give what is thought of as immaterial a solid form. Objects that intersect or that are composed of two or more forms provide an infinite study in themselves.

GEOMETRIC OBJECTS

The basic intersecting forms shown on these pages (Figures 6–1 through 6–10) must be studied from different perspectives; here, there is only one perspective for each. Shade each example and remember to enhance the form with eye compensation. Use pencil in order to become familiar with the endless possibilities.

The examples of Figures 6–1 through 6–10 can be successfully implemented with masking and nothing more. But a larger group of objects, the geometrically nondefinable ones, as seen in Figures 6–11 to 6–15, transcend the elementary masking technique and require substantial free airbrush and shield work.

ORGANIC OBJECTS

Understanding the material structure of the environment enables the artist to express himself or herself. Technical excellence, in airbrush particularly, depends heavily on the understanding of the relationship between light play and the material structures and substructures. When it comes to rendering the organic form, this understanding is even more important. This is because a complex form is open to many interpretations. If you look at Figure 6–12, you will see that an identical shape is transformed into four different objects, even though the technique required is the same for all four. Here, as in much of airbrush art, it is the *concept* that guides the artist's hand and leads to the final image.

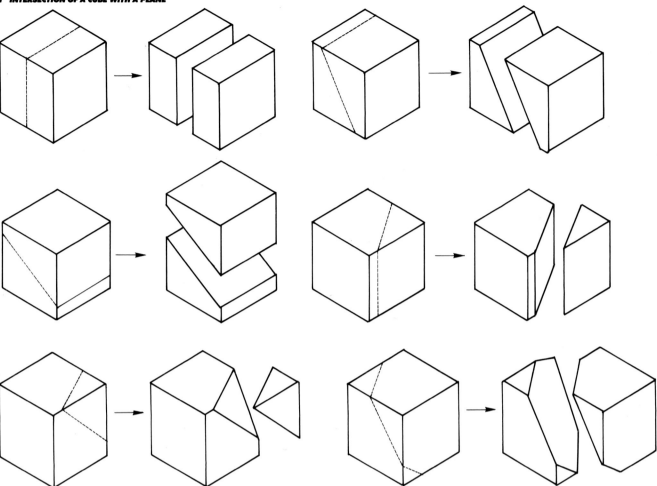

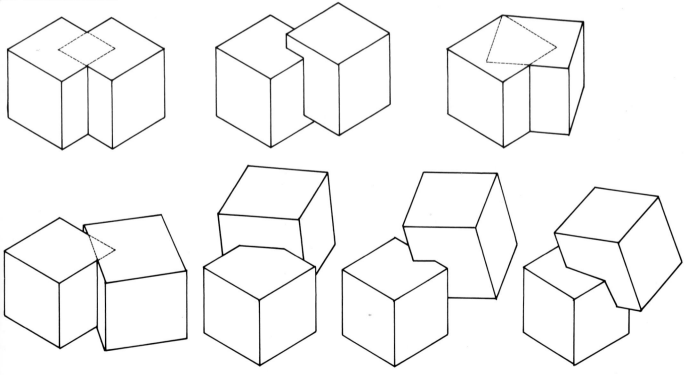

6-3 INTERSECTION OF A CYLINDER WITH A PLANE

6-4 INTERSECTION OF A CUBE AND A CYLINDER

6-5 INTERSECTION OF TWO CYLINDERS

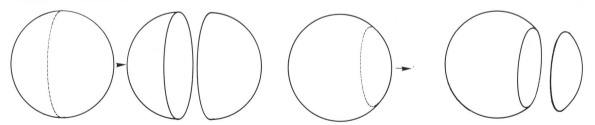

6-6 INTERSECTION OF CONES WITH PLANES

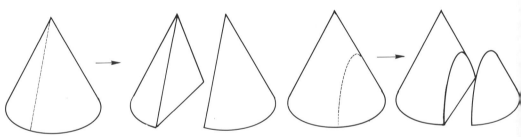

6-7 INTERSECTION OF SPHERE WITH PLANES

6-9 INTERSECTIONS OF SPHERES WITH CUBES

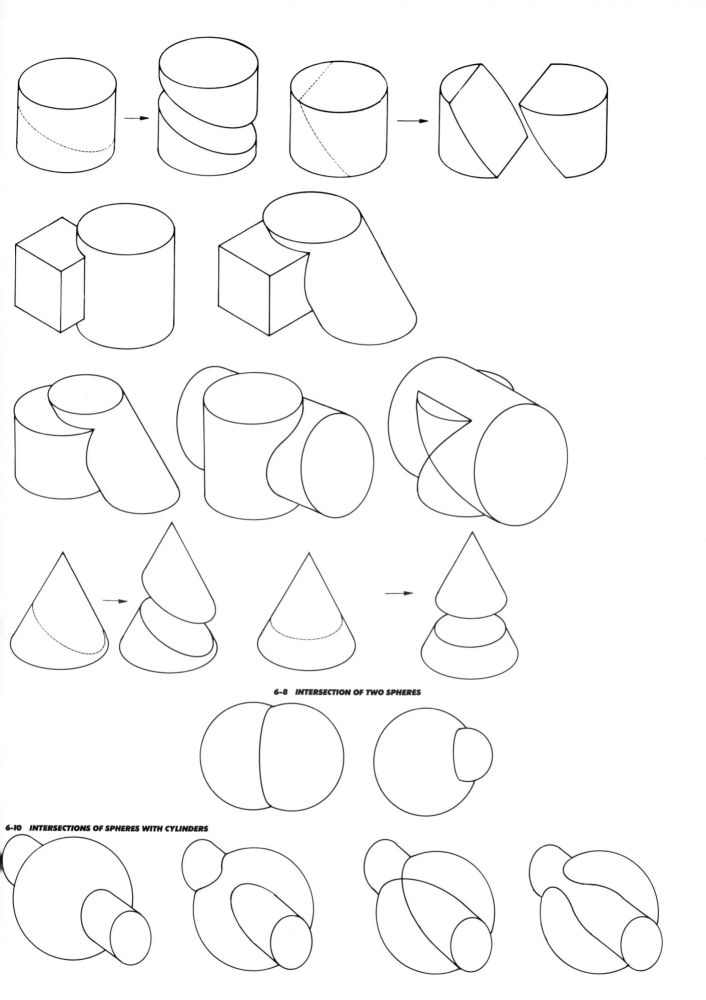

6-8 INTERSECTION OF TWO SPHERES

6-10 INTERSECTIONS OF SPHERES WITH CYLINDERS

Magnified Detail of Wrinkled Skin

Support: 100W

Step 1: F (O) $30Y_3$ + 10Co + 60W + $10Bl_3$ R_5 D_{80-100}(overall color)
Step 2: F (T) Rd_1 R_5 D_{5-10}(upper part)

Step 3: S (O) $30Y_3$ + 20Co + 30W + $20Br_5$ R_2 D_{100} D_0(first shadow)
Step 4: F (O) Same as Step 3: R_{10} $D_{10} \rightarrow D_{50}$(second shadow)

ep 5: ⑤ (O) 100Br$_5$ R$_2$ D$_{100}$ → D$_0$
ep 6: Ⓕ (O) Same as Step 5: R$_{10}$ D$_{10}$ D$_{50}$
ep 7: ⑤ (O) 30G$_2$ + 30W + 30Br$_5$ R$_2$ D$_{100}$(counterlight)
ep 8: ⑤ (O) 80W + 20Y$_3$ R$_2$ D$_{100}$(first light tone)

Step 9: ⑤ + Ⓑ 100W(highlight)

Note: Step 2 represents a change in the tonality of the wrinkled skin. Steps 4 and 6 are necessary to show that the underlying structure of the face has its own curvature within which the wrinkles are rendered.

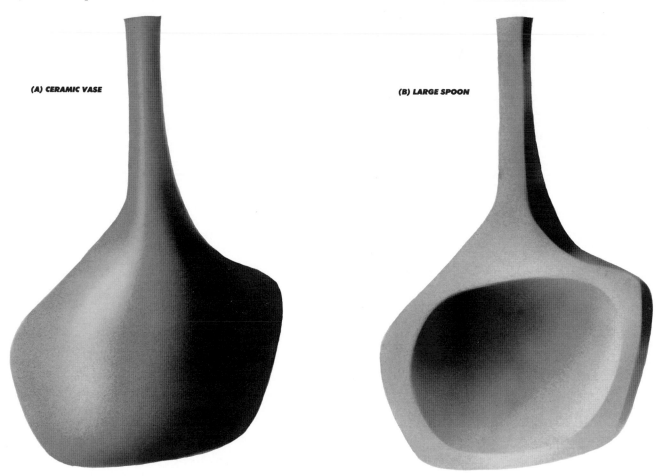

(A) CERAMIC VASE

(B) LARGE SPOON

Support: 100W

TECHNIQUE FOR ALL

Step 1: Ⓜ (O) 100Co(at various densities)
Step 2: Ⓕ + Ⓢ $100Br_5$ R_2 $D_{100} \rightarrow D_0$
Step 3: Ⓕ + Ⓢ $100Rd_5$ R_2 $D_{100} \rightarrow D_0$
Step 4: Ⓕ + Ⓢ $100G_1$ R_2 $D_{100} \rightarrow D_0$
Step 5: Ⓕ + Ⓢ $100W$ R_2 $D_0 \rightarrow S$

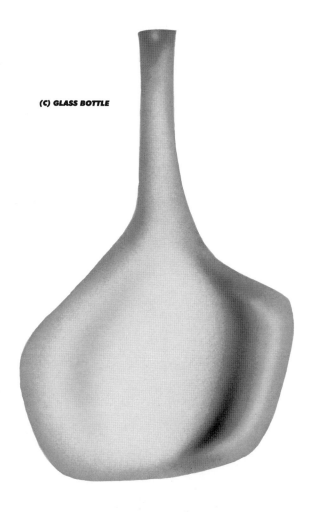

(C) GLASS BOTTLE

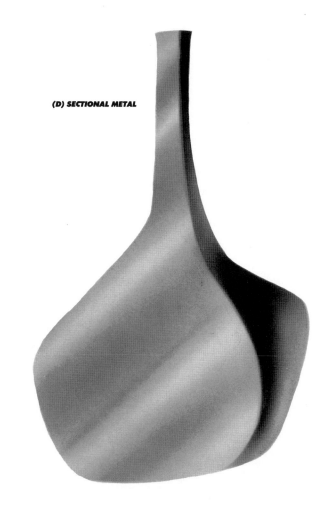

(D) SECTIONAL METAL

Assignment

Render three red, fresh-looking radishes. Note that they are geometrically nondefinable units similar to distorted spheres. As the two dominant colors are white and red, select a dark background but don't use black because you will want to keep the shadows on the ground. This problem can be solved in several ways:
Support: 100W
1. F (T) Rd, then (O) background B or M, or
2. M (O) background M shadow M radishes, or
3. M (O) radishes B or M background, or
4. F (O) background complete, then render radishes.
 The same effect can be obtained if the support is red or brown or any convenient color that will harmonize with the red of the radishes.
 When rendering the radishes, remember to begin spraying the intermediary tone first, relating it to the color of the support and to the final tone you wish to obtain. If more than one intermediate tone is needed, then the first one should be closer to the support's color. On a 100W support begin rendering the red radish surface with a 80W + 20Rd, then continue with only one or two tones of red until reaching the desired intensity. Be sure that the white used for the stems of the radishes is different from the white used for highlights on the red areas because a highlight is more brilliant than the off-white of the stem. The word *fresh* indicates the sensation of crispness and moisture, hence the use of a brush for 100W highlights.

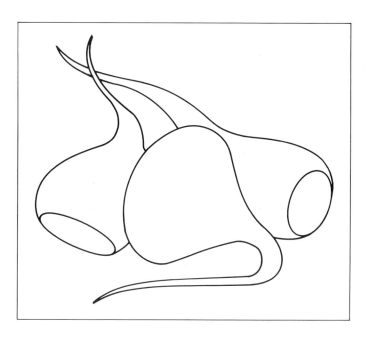

Geometrically Definable Agglomeration: Small Spheres

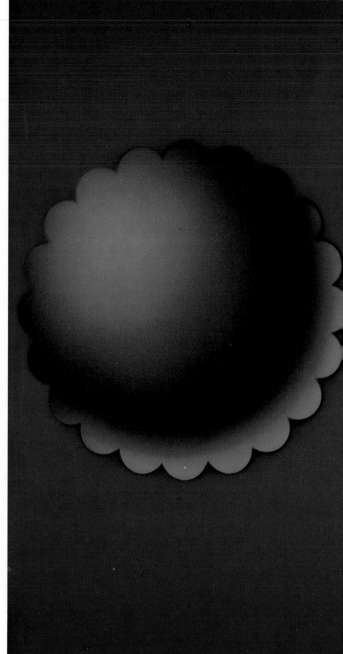

Support: Rd$_5$

LARGE SPHERE

Step 1: Ⓜ (O) 100Bk R$_4$ D$_{100}$(uniform color)
Step 2: Ⓜ (O) 50Bk + 50W R$_3$ D$_{100}$ → D$_0$(first light)

Step 3: Ⓜ (O) 80W + 20Bk R$_3$ D$_{100}$ → D$_0$(second light)
Step 4: Ⓜ (O) 100G$_1$ R$_3$ D$_0$ → D$_{80}$(counterlight)

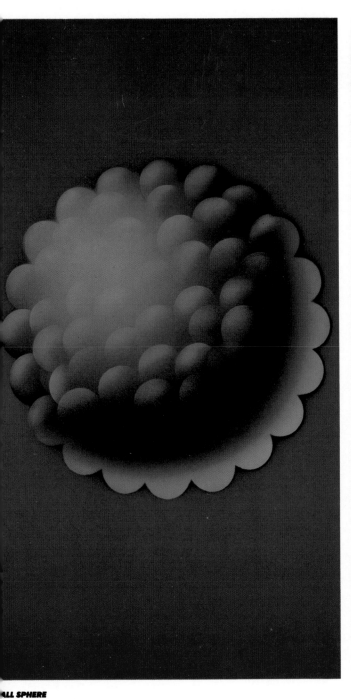

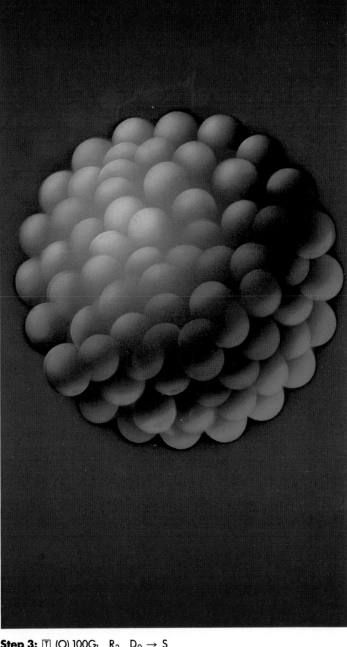

ALL SPHERE

Step 1: ⊤ (O) 50W + 50Bk R_2 D_{80-0}
Step 2: ⊤ (O) 100W R_2 D_{100} → S

Step 3: ⊤ (O) 100G_1 R_2 D_0 → S
Step 4: ⊤ (O) 100G_1 R_2 D_0 → S

Note: As a general rule, whenever a large body is formed of multiple subunits, you should render the total body first and then render the subunits according to the large light and shade areas.

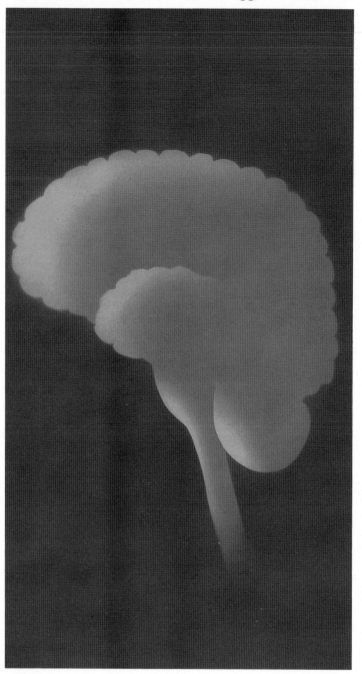 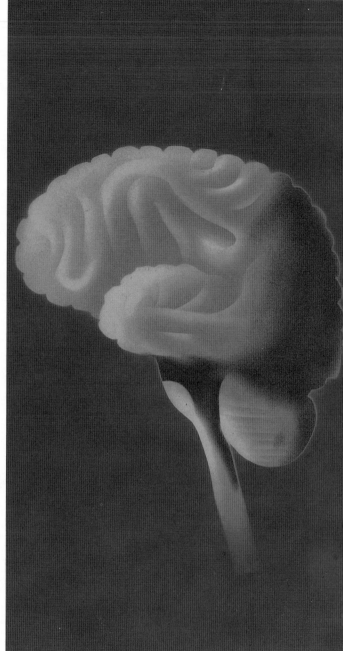

Support: 70Bl$_5$ + 30W

Step 1: Ⓜ (O) 50W + 50Bk R$_5$ D$_{100}$(uniform color)
Step 2: Ⓜ (O) 80W + 20Bk R$_3$ D$_{100}$ → D$_0$
Step 3: Ⓢ (O) 80W + 20Bk R$_2$ D$_{0\text{-}100}$

Step 4: Ⓜ (O) 70Br$_5$ + 15Bk + 15W R$_5$ D$_0$ → D$_{100}$

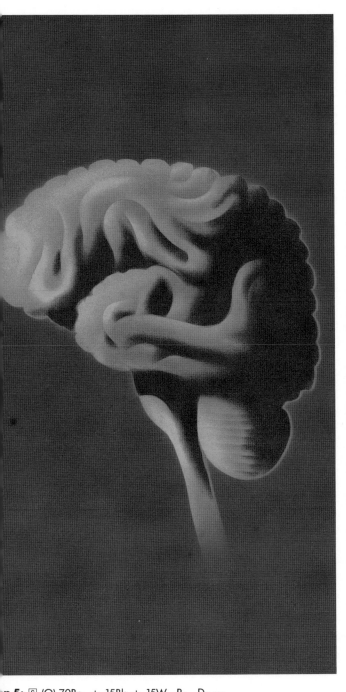

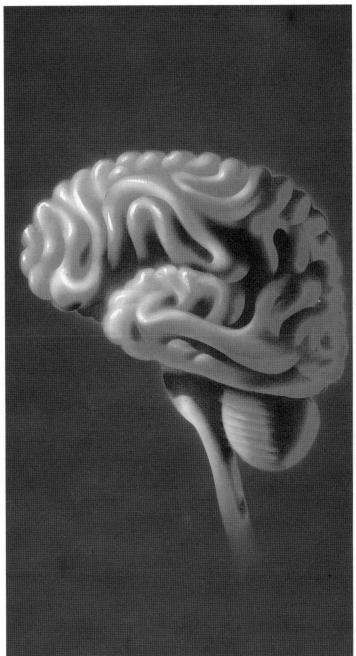

Step 5: Ⓢ (O) 70Br$_5$ + 15Bk + 15W R$_2$ D$_{0-100}$
Step 6: Ⓢ (O) 100Rd$_5$ R$_2$ D$_{0-100}$

Step 7: Ⓢ (O) 50W + 50Bl$_4$ R$_2$ D$_{0-100}$(counterlight)
Step 8: Ⓢ (O) 100W R$_2$ D$_{0-100}$
Step 9: Ⓑ (O) 100W(highlights)

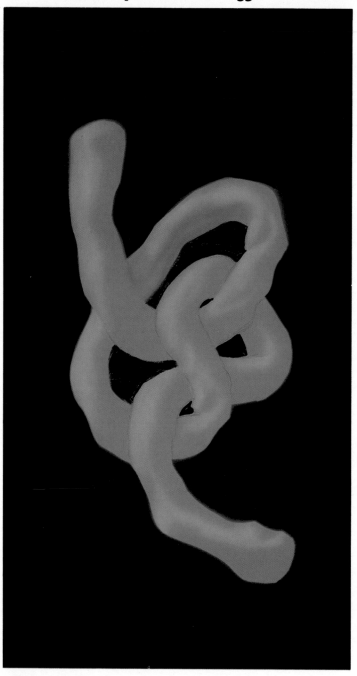

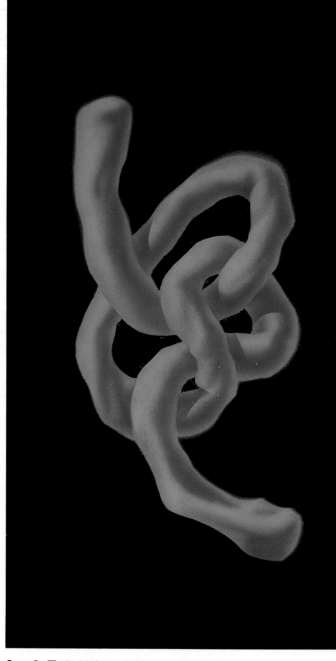

Support: 100Bk

Step 1: Ⓜ (O) 50Bl$_4$ + 50W R$_3$ D$_{100}$(uniform color)

Step 2: Ⓜ + Ⓢ (O) 30Bl$_4$ + 70W R$_2$ D$_{0-100}$

Step 3: Ⓢ (O) 50Bl$_4$ + 50Bl$_5$ R$_2$ D$_{0-100}$

Note: Observe that the highlights on 6-14 are indicated with Ⓑ, whereas the highlights on 6-15 are indicated with Ⓢ. This is because the brain is covered by a smooth and moist membrane that gives it a glossy aspect, which is best achieved by a brush. The plasteline is generally dull and a shield works best. Sometimes, however, the plasteline is covered with an oily substance and a brush is needed to paint on the white highlights.

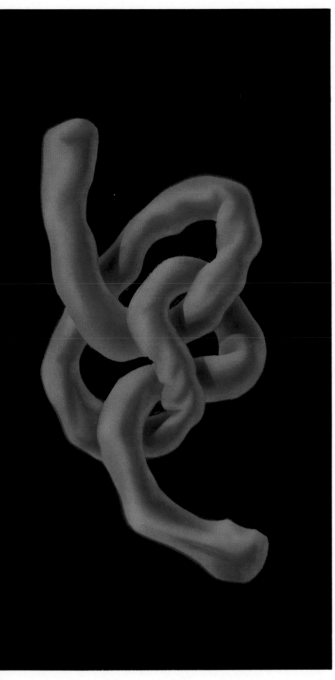

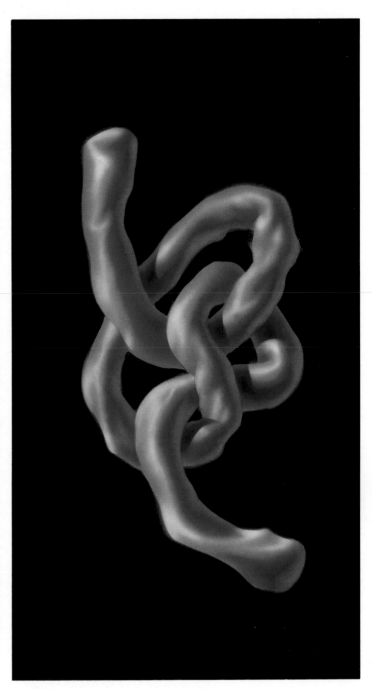

p 4: Ⓢ (O) 20Bl$_4$ + 80Bl$_5$ R$_2$ D$_{0-100}$(accents on shadow)

p 5: Ⓢ (O) 50Rd$_4$ + 50W R$_2$ D$_{80-100}$(counterlight)

Step 6: Ⓢ (O) 100W R$_2$ D$_{100}$ S(highlights)

Chapter 7

Texture

Rendering a simple geometric object is relatively easy, but to imagine various objects made of the infinite variety of textures in the material world requires an additional effort that invariably begins with observation. For example, the play of light on an object's structure usually identifies the material from which it is made. Often an artist's analytical observation of structure must go to the microscopic level. In such cases, it is necessary to differentiate between looking and seeing. It is one thing to *look* at an object and know that it is made of wood, but to understand what makes us so sure about our realization we must *see*. Looking is related to primary perception and emotional response, whereas seeing is related to logical analysis. You should practice observing analytically the detail that gives life to a realistic rendering.

For example, rendering reflections on mirrored spherical surfaces made of highly polished metal requires a profound understanding of spherical projective geometry, which is, of course, beyond the scope of this book. It is sufficient to say here that such surfaces are airbrushed not so much as solids but as distorted reflections of the objects around the observer and around the surface (Figure 7–2). When such a rendering is required, the best thing to do is to study a mirrored, curved surface, make a detailed drawing of it, then render it with the aid of masks.

Polished metal surfaces (Figures 7–1, 7–3) reflect light strongly, but a dull finish softens the contrast between light and shadow to an almost velvety uniformity. Note that in the treatment of metals, the counterlights about the edges have been neglected in order to keep the visual explanations simple. Study hardware and metal appliances around the house in order to verify and better understand these metal-light interactions.

Cloths such as velvet and silk reflect light in very different ways. Velvet (Figure 7–4) is covered with short hairlike threads that reduce the light reflection; on the other hand, silk (Figure 7–5) is formed of very smooth fibers that reflect light more strongly.

The main difference between cloth and metal lies in the geometric rigidity of the metal as opposed to the nongeometric softness of the fabric. Thus, rendering metal requires the airbrush mask, whereas fabric can be rendered most freely using the airbrush shield and free airbrush. An exception to this general rule would be when you are rendering a metal object that includes fabriclike folds, such as a draped metal sculpture. In such a case, the use of an airbrush shield and free airbrush would dominate, and the identifying factor becomes the uniform color of the metal used for the fabric and for other components of the sculpture (like the skin).

ep 1: Ⓜ (O) 30Bk + 70W R₅ D₁₀₀(uniform color)
ep 2: Ⓑ (O) 90W + 10Bk(left edge)
ep 3: Ⓑ (O) 70Bk + 30W(right edge)

Step 4: Ⓜ + Ⓕ (O) 60Bk + 40W R₂ D₀₋₁₀₀
Step 5: Ⓜ + Ⓕ (O) 100W R₂ D₀₋₁₀₀
Step 6: (O) 100W(highlight on edge)

Note: Use ruling pen for Step 6.

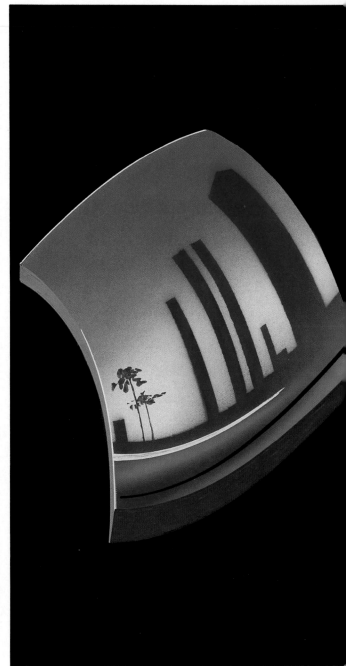

Support: 100Bk

Step 1: Ⓜ (O) 100W R_5 D_{100}(uniform color)

Step 2: Ⓜ (O) 100Bl$_4$ R_4 D_{100} ↓ D_0

Step 3: Ⓜ (O) 100Bl$_2$ R_{2-3} D_{100}

Step 4: Ⓑ (O) 100Bl$_2$(trees)

Step 5: Ⓜ (O) 50Y$_3$ + 50W R_3 D_{100} ↑ D_0

Step 6: ✳ (O) 100W + 100Bk

Step 7: Ⓑ (O) 60W + 40Bk(left edge)

Step 8: Ⓑ (O) 10Bl$_5$ + 50Bk + 40W(bottom edge)

Note: Use ruling pen for white edges.

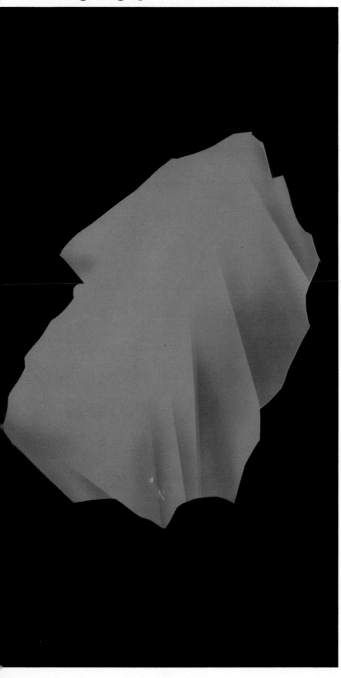

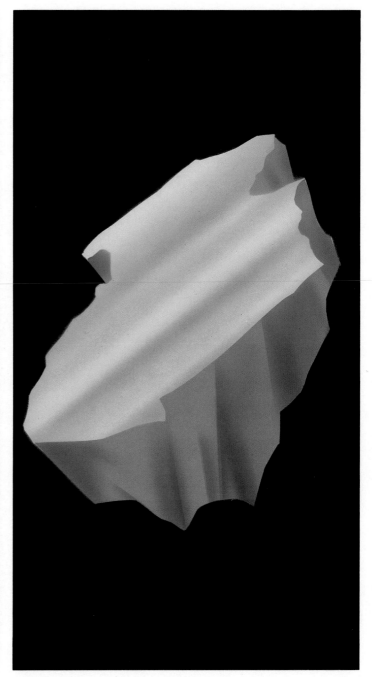

port: 100Bk

p 1: Ⓜ 100Y$_3$ R$_5$ D$_{100}$(uniform color)

p 2: Ⓜ + Ⓢ 100R$_5$ R$_3$ D$_{0-100}$

Step 3: Ⓜ 100Y$_1$ R$_3$ S

Step 4: Ⓕ 100Br$_3$ R$_2$ D$_{30-40}$(within Ⓜ)

Step 5: Ⓕ 100W R$_2$ S(within Ⓜ)

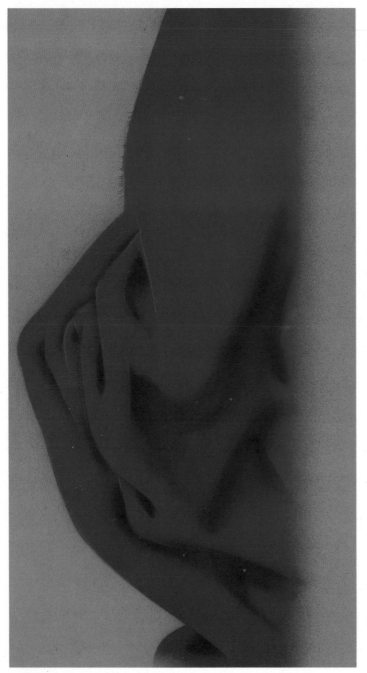

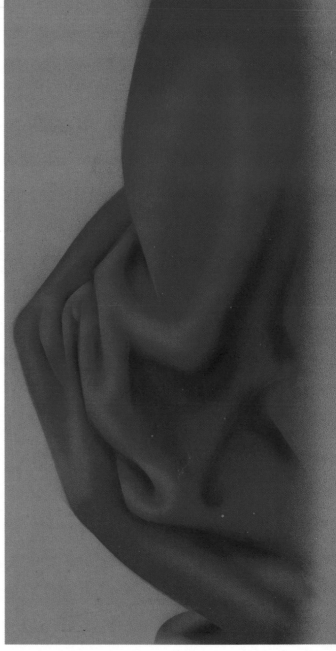

Support: 70W + 25Bk + 5Y$_3$

Step 1: Ⓢ (O) 100Bl$_1$ R$_{2,4}$ D$_{100}$ → D$_0$
Step 2: Ⓢ (O) 100Bl$_5$ R$_2$ D$_{0\text{-}100}$

Step 3: Ⓢ (O) 80Bl$_1$ + 20W R$_3$ D$_{0\text{-}100}$

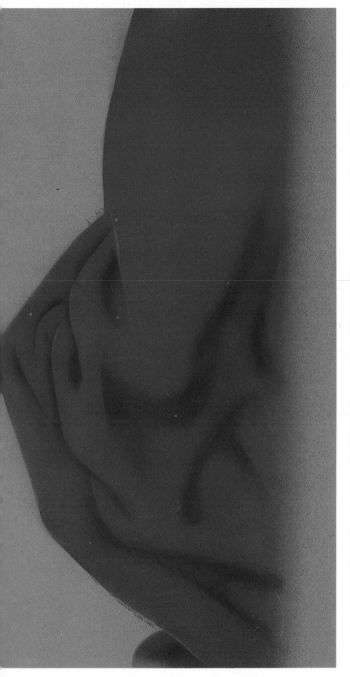

port: 70W + 25Bk + 5Y$_3$

p 1: Ⓢ (O) 100Bl$_1$ R$_{2,4}$ D$_{100}$ → D$_0$
p 2: Ⓢ (O) 100Bl$_5$ R$_2$ D$_{0\text{-}100}$

Step 3: Ⓢ (O) 20Bl$_1$ + 80W R$_2$ D$_{0\text{-}100}$(highlight)
Step 4: Ⓢ (O) 100W R$_2$ D$_{0\text{-}100}$(highlight2)

Support: 100W

Step 1: ⑂ (T) 80W + 10Y$_1$ + 10Br$_5$ R$_{10}$ D$_{30}$
Step 2: ⑂ (T) 60W + 20Y$_1$ + 20Br$_5$ R$_3$ D$_{50}$

Step 3: ⑂ (O) 60W + 40Br$_5$
Step 4: ⑂ (O) 60W + 40Br$_5$ R$_2$ D$_{0\text{-}100}$

Assignment

Render the illustration shown, following these specifications and explanations carefully: The drawing represents a room in which walls marked *a* are mirrors, the ceiling is light blue, and the background wall, *b*, is made of wood, the floor is red granite tile, and the object on the floor is a white marble pedestal supporting a chrome sphere. There are several problems to solve here.

The ceiling can be airbrushed uniformly with $70W + 30Bl_3$ and the marble pedestal with $100W$. The background wall, *b*, made of dark oak, can be rendered according to the principles illustrated in Figure 7–6. This rendering of oak can be continued in the left-hand and right-hand mirrored reflections.

In order to separate the actual wall from its reflections, use an ⓂM (O) $90W + 10G_1 R_8 D_{30} \rightarrow D_0$ for the right wall, using the same (but $D_0 \rightarrow D_{30}$) on the left wall near the corners of the room. Only then can you trace the vertical black lines, *v*, separating the mirror panels.

To create the tile floor, spray the floor area first, using the appropriate uniform tone of red to represent the granite, then spatter this toward the front with some darker tone to obtain the structure of polished granite tile. This spattering can be obtained either by spraying a thick fluid under low compressor pressure, or by using a toothbrush dipped in color and then gently stippling the surface.

To obtain the image of a polished floor, the reflections of the walls and pedestal should be seen on the floor. These reflections can be lightly sprayed along the dotted vertical lines, with the appropriate lighter tones of the elements reflected (i.e., the lighter tone of the mirrored walls and $100W D_{60} \downarrow D_0$ under the pedestal). Now we can trace the black grid between the tiles; this has no reflection.

The chrome sphere presents another problem of reflection, the problem of spherical mirroring. Here, the sphere should be rendered in grays with some reflections of the blue ceiling, the granite floor, and the mirrored walls. In order to simplify the assignment, consider a diffuse, uniform light source that will not create shadows.

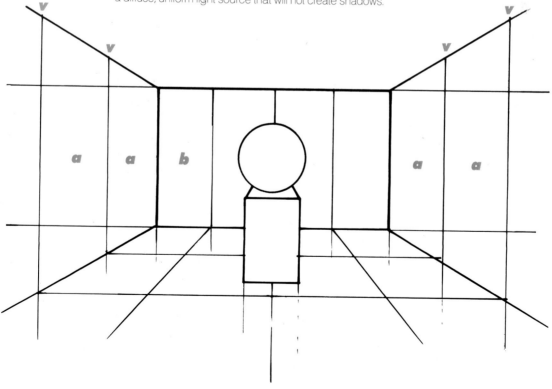

Chapter 8

Transparency

Transparent materials, whether liquid or solid or gaseous, flexible or rigid, colored or clear, share a characteristic that makes them interesting to the airbrush artist: You can see through them. Therefore, in many situations, the rendering of transparent materials is suggested rather than overworked, and the background and objects behind the transparent screen remain visible and are rendered first. If the transparent material or object is hollow or a plane, as in Figure 8–1, the objects behind it are rendered as they normally would be, whereas transparent objects that are solid or filled with a liquid such as lenses, bottles full of water, crystal prisms, or glass sculptures (Figure 8–2), will distort the objects behind them according to the laws of refraction.

As refraction is a complex and delicate study, it is important to carefully observe each particular case to be rendered, and to work from those observations accordingly. For instance, Figure 8–3 represents a drop of liquid. One way to look closely at the way drops of water behave is to put a drop of maple syrup on blue paper and study it under powerful light with a good magnifying glass. Unlike water, maple syrup will not evaporate and will hold its shape. The natural richness of reflections, diffractions, shades, and shadows in the tiny drop creates a surprising color complexity that cannot be visualized or imagined without observation. The artist, of course, is free to ignore or change or select some of these optical interactions between light and object, but such studies are recommended for two reasons: 1. In order to ignore, change, or select, you must first understand what is there. 2. New images enrich your memory file.

Figure 8–4 represents bubbles of soap. This liquid formation is renowned for its richness of color. On its surface you can see the colors reflected from surrounding objects as well as colorful rainbow patterns. These patterns are created because a bubble is formed of more than one shell of molecules, each diffracting the surrounding white light into its elementary components. Since the molecular cohesion between these shells is weak, the color patterns slide in between each other and create a colorful motion.

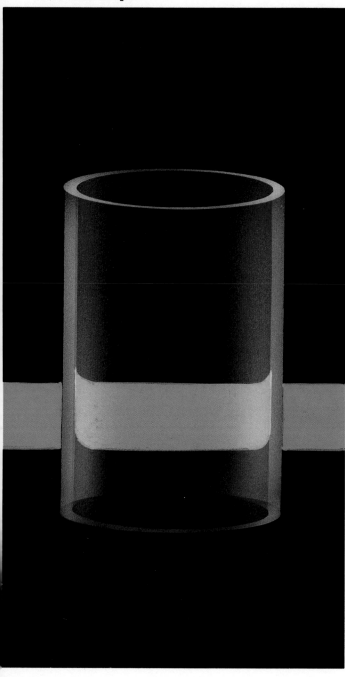
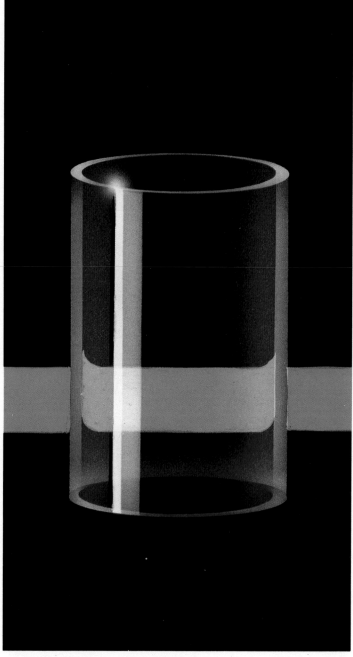

Support:

Step 1: Ⓑ (O) 100Co

Note: The stripe of orange is necessary to show transparency and also refraction.

Step 2: Ⓜ (O) 100W R_4 D_{30}
Step 3: Ⓜ + Ⓢ (O) 100W R_3 D_{50}(left and right vertical edges)
Step 4: Ⓜ (O) 100W R_2 D_{80}(upper and lower edges)

Note: Cut negative ellipse (large) and positive one (small) and hold them in place with pliers.

Step 5: Ⓜ (O) 100W R_3 D_{80}(vertical light)
Step 6: Ⓜ (O) 100W R_2 D_{100}(highlight)
Step 7: Ⓕ (O) 100W R_2 D_{100}(upper starlight)
Step 8: Ⓑ (O) 100Bk(for retouching if necessary)

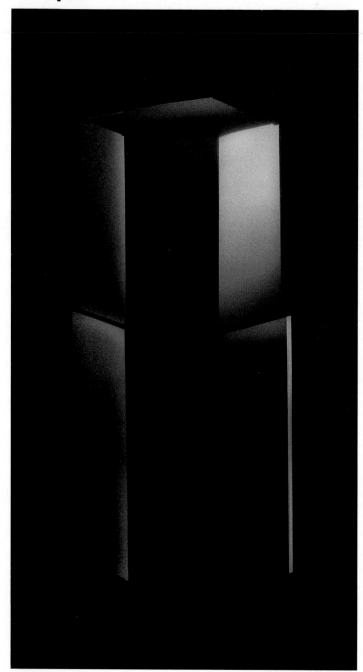 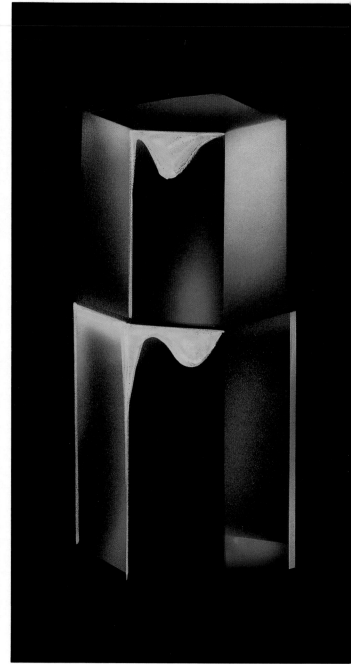

Support: 100Bk

Step 1: Ⓜ (O) 100W R_2 $D_{0\text{-}100}$

Step 2: Ⓑ (O) $100Y_1$
Step 3: Ⓢ (O) $100Y_1$ R_2 D_{100} ↕ D_0
Step 4: Ⓢ (O) $50Bl_3$ + $50W$ R_2 D_{100} ↕ D_0

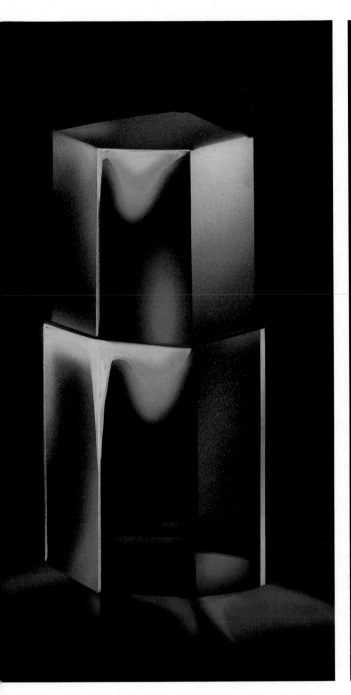

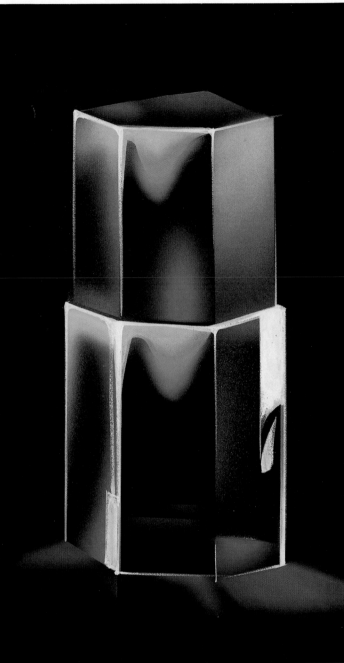

p 5: ☐F (O) 100Co R_2 D_{100}
p 6: ☐S (O) 30W + 30Bk + 20Co + 20Bl₃ R_2 D_{100}
D₀(light on ground)

Step 7: ☐B (O) 100W

 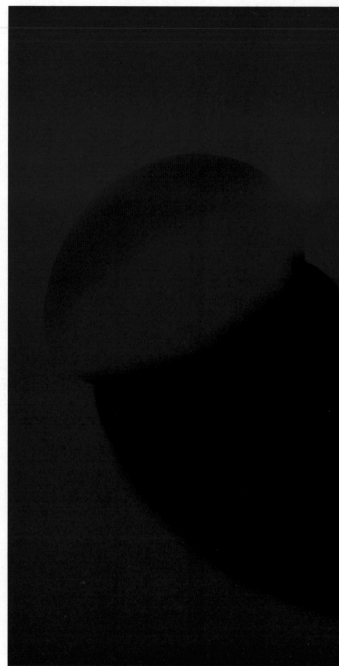

Support: 100Bl$_1$

Step 1: 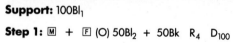 M + F (O) 50Bl$_2$ + 50Bk R$_4$ D$_{100}$

Step 2: M (O) 100Bl$_2$ R$_3$ D$_{100}$ D$_0$

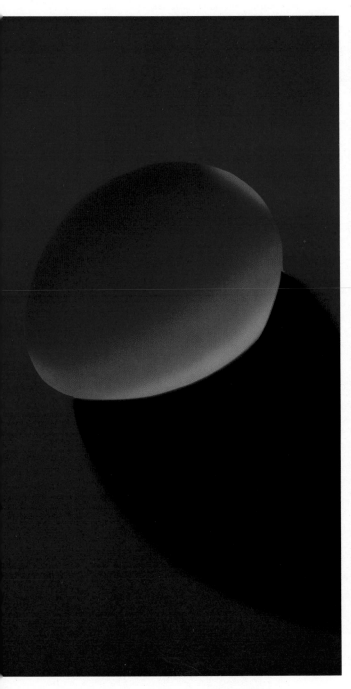

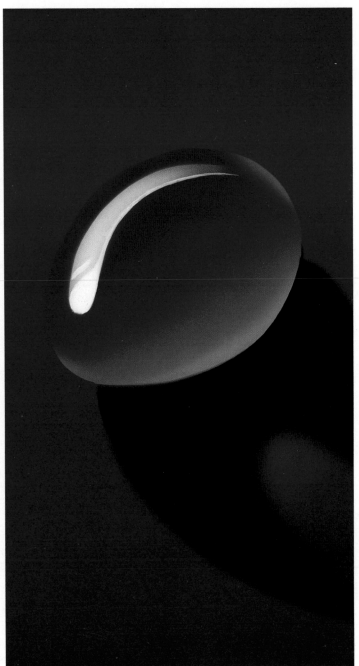

Step 3: Ⓜ (O) 50Bl$_1$ + 50W R$_3$ D$_{100}$ ↑ D$_0$(first light layer)
Step 4: Ⓜ (O) 80W + Bl$_3$ R$_2$ D$_{100}$ S(second light layer)

Step 5: Ⓜ (O) 100W R$_2$ D$_{100}$ → D$_0$
Step 6: Ⓑ (O) 100W(accents)
Step 7: Ⓑ (O) 50Bl$_2$ + 50Bk(retouch of drop curve)
Step 8: Ⓕ (O) 100Bl$_1$ R$_3$ D$_{100}$(light within shadow)
Step 9: Ⓕ (O) 50Bl$_1$ + 50W R$_2$ D$_{30}$(buildup of light within shadow)

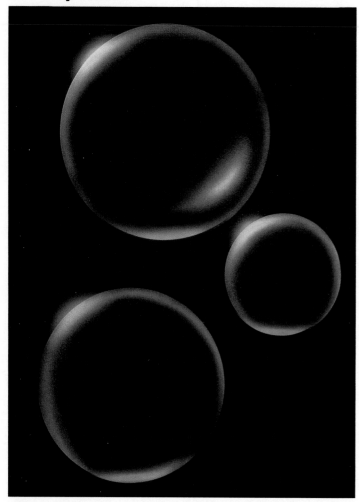

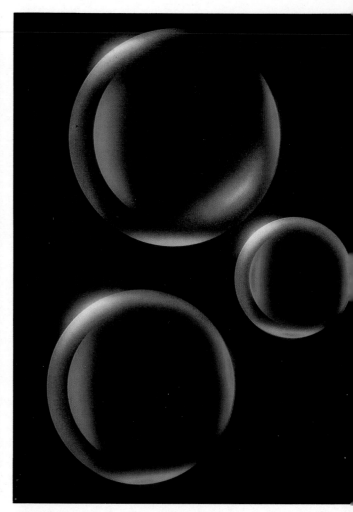

Support: 100Bk

Step 1: ⊤ (O) 100W R_1 D_{0-100}

Step 2: ⏍ (O) 100W R_2 D_{100} → S

Step 3: ⊤ (O) 50Bl$_1$ + 50W R_2 D_{0-100}

Assignment

Render the drawing of a wine glass. Then, show the same glass placed in front of a beach, the sea, the sky, and the setting sun. This scenario may seem contrived but, in fact, this type of illustration is used frequently in advertising for the promotion of wine, perfume, and other products.

Here, however, we are concerned with rendering color transparency. Glass, wine, and sea water are all transparent, but each represents a different type of problem. The sea at this distance loses its transparency and reflects the blue sky or the color of the sunset. The glass can be defined entirely with opaque white using a brush and a mask, and the red wine suggests the use of a transparent madder carmine (Rd_3).

Showing the sun through the wine presents another interesting

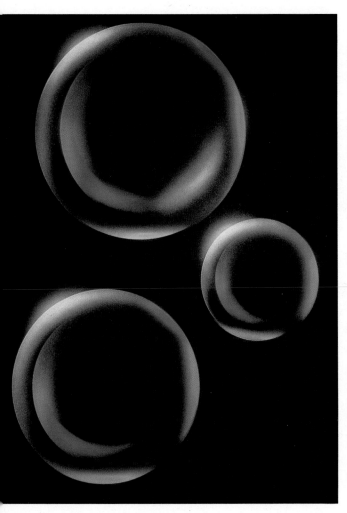

ep 4: Ⓣ (O) 80Rd₄ + 20W R₂ D₀₋₁₀₀

Step 5: Ⓜ (O) 100W R₂ D₈₀ ↑ S

problem. The yellowish white of the sun should become a powerful red and the difference between its image and the rest of the wine should be clearly rendered. You can achieve this by first spraying the sun magenta red (Rd₂) and then carefully surrounding it with an airbrush free madder carmine (Rd₃).

The entire harmony of the composition depends upon your initial concept of what you want to convey about the wine. It could be the lightness of the wine or the happy feeling it engenders. Each concept must be treated accordingly. If the first concept is preferred, brighten the sky at the top, make the reds less intense, and make the sea look luminous. To create a "happy feeling," the whole composition can be made softer by using pastel (but brilliant)

Chapter 9

Ambiance

*A*mbiance is the atmosphere or environment that an object exists within. Understanding how objects are visually influenced by their environment is an important first step toward artistic achievement.

Ambiance falls into two categories: 1. a given colored background that the objects must relate to; and 2. a changing environment that the objects relate to. In the first situation, the artist must render a particular object or objects on a background color that has already been painted and cannot be altered. The objects must be harmonized with it accordingly and should be rendered either by altering the color that is adjacent to the background or by altering the entire color, as shown in Figures 9–1 and 9–2.

There are also changes in the rendering of objects as a result of atmospheric, seasonal, or temporal conditions. Facility in rendering such conditions will help when you wish to create atmosphere or mood in your work. Color harmonies can be visualized and shifted in an infinite number of ways, as you will see. Our examples (Figures 9–3, 9–4, and 9–5) are devoid of subtle detail; only fundamental changes are presented so that you understand the basic canvas on which to render and play with appropriate finishing touches.

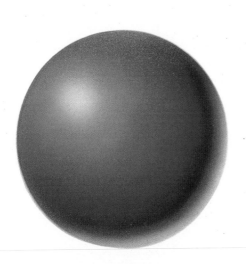

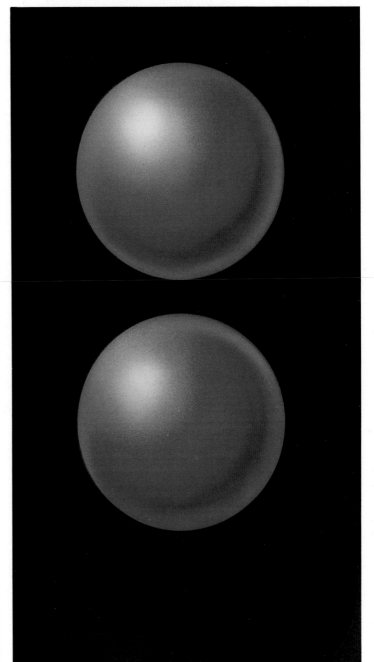

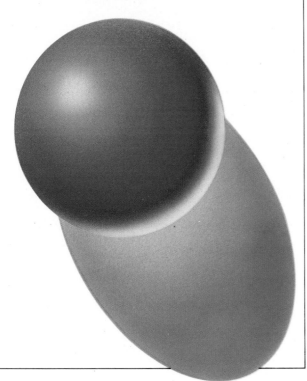

Support: 100W

TOP BALL (FLOATING)
Step 1: ⊤ (O) $100Rd_1$ R_5 D_{100}
Step 2: ⊤ (O) $100Rd_3$ R_3 D_{0-100}
Step 3: ⊤ (O) $100Rd_5$ R_2 D_{0-100}
Step 4: ℉ (O) $100Co$ R_3 D_{0-100}
Step 5: ℉ (O) $100W$ R_2 S
Step 6: ⊤ (O) $100W$ R_2 D_{30}(counterlight)

BOTTOM BALL (ATTACHED TO WALL)
Step 1: ⊤ (O) $30Bk$ + $70W$ R_3 D_{100-30}(shadow)
Step 2: Follow Steps 1-5 as in Top Ball above
Step 3: ⊤ (O) $100W$ R_2 S(counterlight)

Support: 100Bk

TOP BALL (FLOATING)
Step 1: ⊤ (O) $100Rd_1$ R_5 D_{100}
Step 2: ⊤ (O) $100Rd_3$ R_3 D_{0-100}
Step 3: ⊤ (O) $100Rd_5$ R_3 D_{0-100}
Step 4: ⊤ (O) $100Co$ R_3 D_{0-100}(all around including counterlight)
Step 5: ⊤ (O) $100W$ R_2 $S-D_{30}$

BOTTOM BALL (ATTACHED TO WALL)
Step 1: ⊤ (O) $80Bk$ + $20W$ R_5 D_{30}(around shadow)
Step 2: Follow Steps 1-3 as in Top Ball above
Step 3: ⊤ (O) $100Co$ R_3 D_{0-100}(only on top; no need for additional counterlight)
Step 4: ⊤ (O) $100W$ R_2 S D_{30}

Sunny Day Ambiance

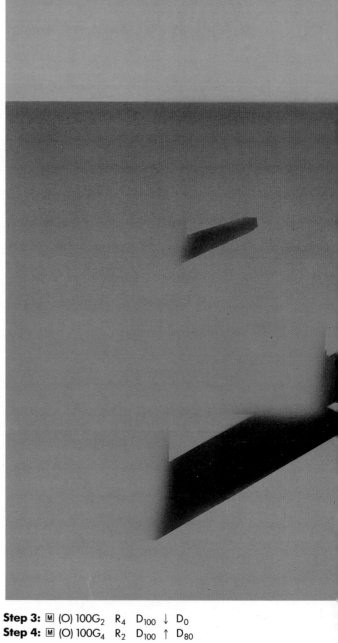

Support: 10W + 50Y$_3$ + 40G$_3$

Step 1: ⑮ (O) 80W + 20Bl$_4$ R$_4$ D$_{80}$ ↓ D$_0$
Step 2: ⑮ (O) 100G$_1$ R$_4$ D$_{100}$ ↑ D$_0$

Step 3: Ⓜ (O) 100G$_2$ R$_4$ D$_{100}$ ↓ D$_0$
Step 4: Ⓜ (O) 100G$_4$ R$_2$ D$_{100}$ ↑ D$_{80}$

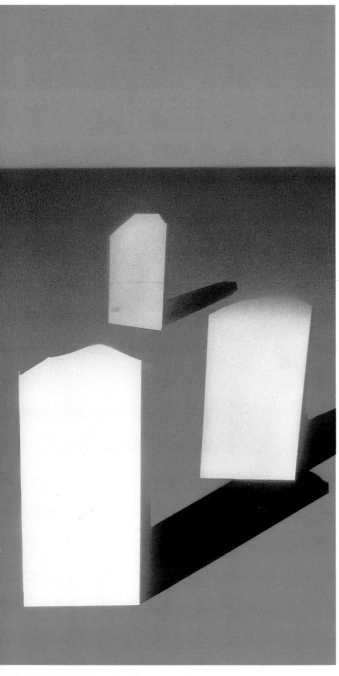

Step 5: Ⓜ (O) 100W R₃ D₉₀(distant stone)

Ⓜ (O) 100W R₃ D₁₀₀(middleground stone)

Ⓜ (O) 100W R₃ S(foreground stone)

Step 6: Ⓑ (O) 95W + 5Bl₄(top of stones)
Step 7: Ⓑ (O) 50W + 50G₂(distant stone, vertical edge)
Step 8: Ⓑ (O) 50W + 25G₂ + 25G₄(middleground stone vertical edge)
Step 9: Ⓑ (O) 50W + 50G₄(foreground stone, vertical edge)
Step 10: Ⓑ (O) 50G₄ + 50R₅(shadow on stone)

Note: The use of a brush can be avoided by cutting additional masks for edges and treating them in a more elaborate way.

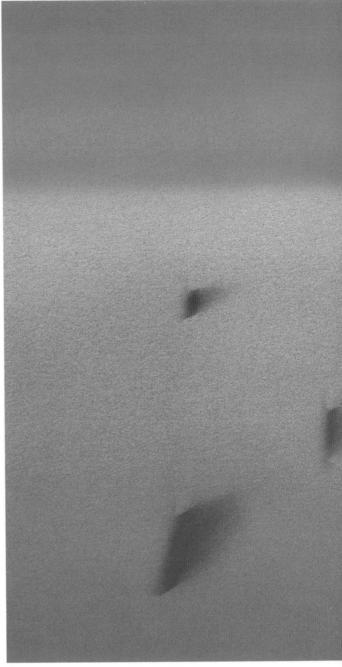

Support: 100W

Step 1: 🄵 (O) 60G₂ + 40W R₅ D₁₀₀ ↑ D₄₀

Step 2: 🄵 (O) 50W + 50Bk R₃ D₁₀₀

Step 3: Ⓜ + 🄵 40G₄ + 50W + 10Bk R₂ D₁₀₀ → D₀

4: Ⓜ (O) 90W + 5Bk + Br₅ R₃ D₁₀₀

Step 5: Ⓑ 95W + 5Bk(tops)
Step 6: Ⓑ 60Bk + 40W(foreground stone, vertical edge)
 Ⓑ 50Bk + 50W(middleground stone, vertical edge)
 Ⓑ 40Bk + 60W(distant stone, vertical edge)

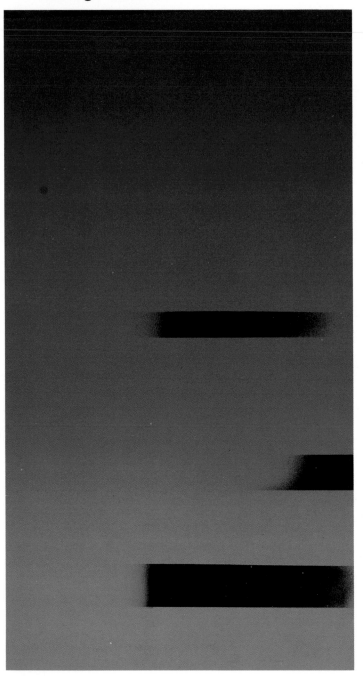

Support: 100Bl$_3$

Step 1: Ⓕ (O) 100Bl$_5$ R$_{10}$ D$_{100}$ ↓ D$_0$
Step 2: Ⓜ (O) 100Bk R$_3$ D$_{100}$ → D$_0$

Step 3: Ⓜ (O) 70Bl$_1$ + 30W R$_3$
Step 4: Ⓜ (O) D$_{80}$ ↑ D$_{40}$(distant stone)
Step 5: Ⓜ (O) D$_{100}$ ↑ D$_{80}$(middleground stone)
Step 6: Ⓜ (O) S ↑ D$_{100}$(foreground)

Following the figure shown, render the tombstones with a sunset ambiance, where the sun is setting at the horizon line, behind the largest stone. As a result, the stones will become quite dark in contrast with the still very powerful light of the hidden sun. Remember that you also have other atmospheric conditions to incorporate into your image, such as whether the day is clear or foggy, hot or cold, humid or dry, or a combination of these environmental factors. For example, a rendering depicting a hot day will require much more reddish tones than a freezing day, or a clear summer day will have much more value contrast than the subtle gray tones of a foggy day.

ep 7: B (O) 10Bl₁ + 90W(foreground and middleground stone, top)
30Bl₁ + 70W(distant stone, top)

ep 8: B (O) 50Bl₁ + 25Bl₃ + 25W(right edges)

Chapter 10

Adjacency

Adjacency is determined by the three-dimensional relationship of the objects rendered. Remote adjacency is when two objects are distant from each other in perspective but next to each other in a two-dimensional rendering. Close adjacency is when the objects are very near or partially overlapping each other three-dimensionally.

Perspective depth needed to convey adjacency can be achieved in two ways. One method is to reduce the size of the objects in relation to their distance from the observer, which is purely a matter of perspective. The other method used to create spatial depth is to reduce color intensity or to change the hues or tones of the remote objects.

In general, the tone of a distant color tends to become more blue, probably because of the reflection of the sky in the atmosphere. Such an effect can be obtained more quickly and easily using the airbrush than it was in classical painting where each detail was carefully painted with the appropriate color. It is much easier to render distant background objects just as you would the foreground objects. A light free airbrush spray of opaque color ($R_{10}D_{10-30}$) used uniformly over the objects is an effective rendering method. Or, if you want, you can just as easily spray background objects first and then continue with the foreground objects, without using spray. Either way the effect of depth is unquestionably obtained.

This technique comes close to simulating the natural phenomenon of the earth's atmosphere—the air cushion formed by milions of molecules and particles. For rendering atmospheric conditions, no other medium produces such an evocative resemblance to the natural world.

Another way to suggest adjacency or depth in a rendering of objects shown in perspective is to introduce shadows. For example, the elongated shadow of a tall structure when the sun is low diminishes in intensity with the distance. This is true because: 1. The air cushion separating the eye from the shadow gets thicker with distance, thus gradually reducing the darkness of the shadow. 2. The surrounding counterlights penetrating the shadowed space increases as the distance increases.

These shadow changes are simply rendered by using Ⓜ (O) $D_{100} \rightarrow D_{20}$ for uniform shadowed grounds, or Ⓜ (T) $D_{100} \rightarrow D_{20}$ for nonuniform shadowed grounds where the details must be preserved by transparence, as seen in Figure 10–3.

The subtler phenomena of hue and tonal nuances are affected by the atmosphere of a rendering. If you compare the final illustrations in Figures 10–1 and 10–2, the color schemes differ substantially. It is clear that Figure 10–2 has a softer appearance than Figure 10–1. On a cloudy day the sun does not simply shine directly on the objects; it is diffused by clouds. As a result the light and the shadows are dimmed. In addition, the counterlights combine with the sun's reflected light, reducing the reflected color and extending the surface touched by the counterlight deeper into the shaded side of the object. As you can see, Figure 10–1 has stronger shadows.

The variations possible between a sunny day and a dark stormy one are considerable. If we combine these climatic conditions with the time of day or night and the season, the possibilities are infinite.

In addition to the variables of climate and daylight, there are light sources from fire or other light generators such as candles or electricity—all of which can be very colorful. With this wide range of possibilities you can understand situations when the color of an object changes dramatically but doesn't destroy its identity or even the impression of the initial color.

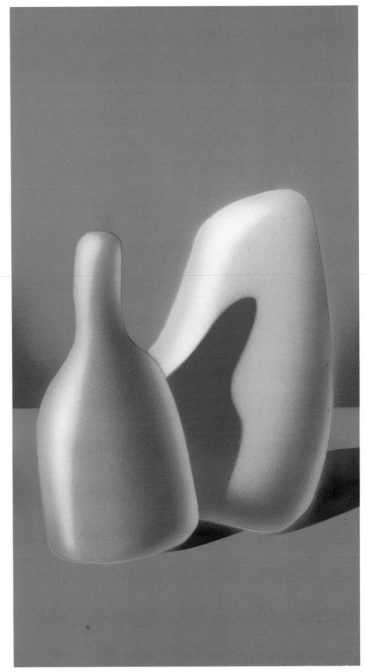

Support: 100G₁

Step 1: Ⓜ (O) 50G₂ + 50G₄ R₃ D₁₀₀ ↑ D₀(wall separation)
Step 2: Ⓢ (O) 80G₄ + 20Bl₅ R₃ D₁₀₀
Step 3: Ⓜ (O) 80W + 15Y₃ + 5Br₅ R₄ D₁₀₀
Step 4: Ⓜ (O) 100Br₂ R₃ D₀₋₁₀₀(shadow and shade)
Step 5: Ⓜ (O) 50Br₂ + 50Rd₅ D₁₀₀ ↓ D₀(shadow build-up)
Step 6: Ⓢ (O) 100W R₂ D₁₀₀₋₀ → S(light)

Step 7: Ⓜ (O) 100Co R₄ D₁₀₀ → S
Step 8: Ⓜ (O) 80Rd₃ + 20Br₅ R₃ D₀ → D₁₀₀
Step 9: Ⓜ + Ⓕ (O) 100W R₂ D₀₋₁₀₀
Step 10: Ⓜ (O) 60Y₁ + 30W + 10G₁ R₂ D₀ → D₁₀₀(counterlight on orange object)
Step 11: Ⓜ (O) 50W + 45G₁ + 5Y₇ R₂ D₀ → D₁₀₀(counterlight on cream-colored object and lower edge of both objects)

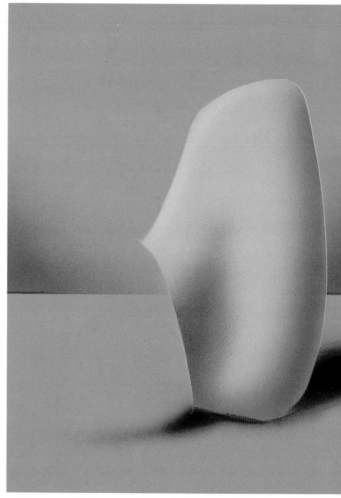

Support: 50G$_2$ + 50W

Step 1: Ⓜ (O) 100G$_3$ R$_3$ D$_{100}$ ↑ D$_0$(wall separation)
Step 2: Ⓕ (O) 80G$_2$ + 20Bk R$_2$ D$_{0-100}$(shadow)

Step 3: Ⓜ (O) 80W + 10Y$_3$ + Br$_5$ R$_4$ D$_{100}$
Step 4: Ⓜ (O) 90W + 10Br$_5$ R$_2$ D$_{100}$ → D$_0$(eye compensation)
Step 5: Ⓜ (O) 80Br$_5$ + 20W R$_3$ F$_{0-100}$(shade + shadow)

Assignment

This simple drawing represents three eggs resting on a pink plate at the edge of a table covered with a light blue tablecloth. On the left stands a lamp with a red lampshade. The background of the composition is very dark. Your problem is to create color harmonies and still have the eggs look white.

Because the source of light is red, the entire composition will be a harmony of reds. For instance, if the tablecloth is light blue, lit by red light, it will become purple. The white eggs will look red. A black background will become harmonious if rendered with an 80Rd$_5$ + 20Bk. The crucial problem is to establish the range of reds between the lamp light and the eggs. The light source will, of course, be stronger than its reflection on the eggs. Remember, however, that the light source will have no shading and the eggs will; the eggs will cast shadows on the plate and on the tablecloth.

The particular shape of the eggs will probably identify them for the beholder, but how should their color be treated? A few factors must be considered first:

1. Since the only white elements in the composition are the eggs, they will be the most luminous detail (apart from the light source) in the whole picture. Therefore, all other elements should be at least 30 percent darker than the eggs. Moreover, if the light source is, let us say, 100Rd$_1$, the eggs will be sprayed with a mask using a mixture of 80Rd$_2$ + 20W, a fainter but brilliant tone of red. (The choice of 80Rd$_2$ + 20W is not absolute; you might find a better color composition than this one. Experiment.)

As eggshells are not glossy, there will be no brush highlight but a R$_2$ to full saturation touch of 70Rd$_2$ + 30W at points *X* where light reflects the strongest. Also, toward the bottom, an addition of a drop of cobalt blue (Bl$_1$) should be made as a faint counterlight from the tablecloth. Note that the tablecloth becomes more intense (lighter) adjacent to the shadow. When the light source is not included in the composition, the problem is simplified; the eggs can become a brighter red in contrast to all the darker red tones of the adjacent elements.

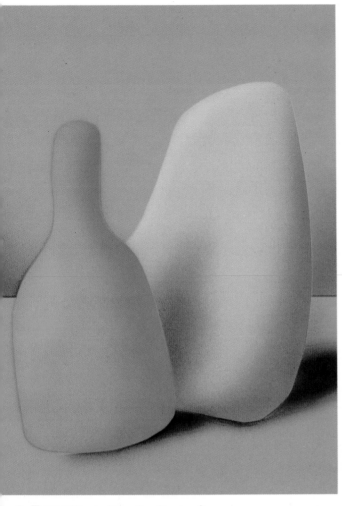

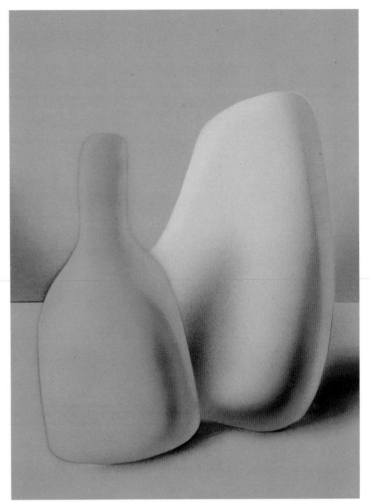

ep 6: Ⓜ (O) 95Co + 5Br$_5$ R$_3$ D$_{100}$ → S
ep 7: Ⓜ (O) 50Co + 50W R$_3$ D$_{100}$ → D$_0$
ep 8: Ⓜ (O) 90Co + 10Br$_5$ R$_3$ D$_0$ → D$_{100}$

Step 9: Ⓜ (O) 30G$_3$ + 10Br$_5$ + 60W R$_2$ D$_{80}$ → D$_0$(left side of orange object)

Step 10: Ⓜ (O) 60W + 30Bl$_3$ + 10Bk R$_3$ D$_0$ → D$_{100}$(upper counterlights)

Step 11: Ⓜ (O) 60W + 30Bl$_3$ + 5Bk + 5Y$_1$ R$_3$ D$_0$ → D$_{100}$(lower counterlights)

Step 12: Ⓕ (O) 70Br$_5$ + 10G$_1$ + 20W R$_2$ D$_{0-100}$(accent on shade and shadow)

Support: $100Bl_1$

Step 1: Ⓜ (O) $100Br_1$ R_5 D_{100}
Step 2: Ⓜ (O) $90W$ + $10Bl_4$ R_3 D_{100} ↑ D_0
Step 3: Ⓕ (O) $90W$ + $10Bl_4$ D_{30} ↓ D_0

Step 4: Ⓜ (O) $100Br_4$ R_2 D_{100} ↑ D_{50}

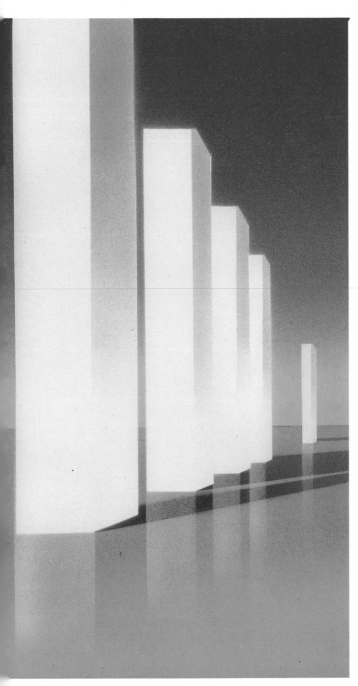
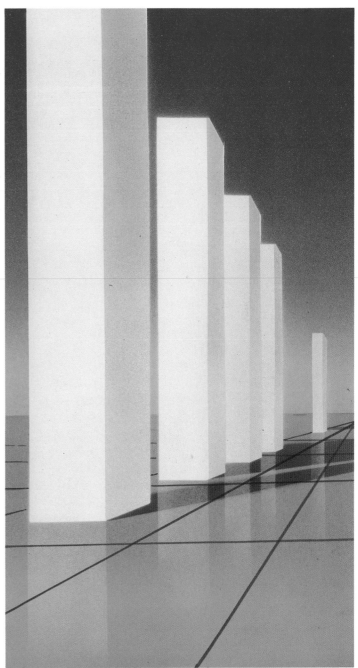

ep 5: Ⓜ (O) 100W R$_3$ D$_{100}$(remove mask)
ep 6: Ⓢ (O) 100W R$_4$ D$_{40}$ ↓ D$_0$(reflection on floor)
ep 7: Ⓜ (O) 50W + 50Bl$_3$ R$_3$ D$_{50}$ ↓ D$_0$

Step 8: Ⓜ (O) 50W + 50Y$_3$ R$_3$ D$_{50}$ ↑ D$_0$(floor counterlight on shaded side)

Step 9: Ⓜ (O) 30Bl$_4$ + 70W R$_4$ D$_0$ ← D$_{50}$(perspective fading of columns)

Step 10: Ⓑ (O) 100Br$_5$(tile lines)

Note: In Step 10 a brush may be replaced with a ruling pen. Also, consider finishing the columns first with transparent medium, covering them with frisket, and completing the rest on a 100W support. The results will be identical to the above formula.

Chapter 11

Immateriality

Immateriality, in the context of this book, is a term meant to convey those natural phenomena, such as energy or atomic particles, that are well defined by science but never actually seen by the human eye. Thus, both these phenomena depend upon the artist's concept. Here, the artist faces a challenge; he or she must take the information known about energy, for example, and create it from his, or her, imagination, thus giving it a material reality.

The world of the occult, mythology, and religion offers another group of immaterial visions, where ghosts, figmentary beings, and gods are apt to be rendered by the artist according to personal fantasy or tradition. In this category of the immaterial there is no logical information at all. Throughout history gods have been rendered in human form. Artists today who depict scientific concepts rely heavily on theoretical data filtered through the imagination.

For example, let us try to illustrate the photon or the quantum of light. Science tells us that light is both wave and particle. The artist therefore has the choice of representing light as one of these properties. The decision depends upon the physical phenomenon the artist wishes to illustrate. If it is light bombardment, the artist might use the "bullet" or particle property. If it is refraction, the artist might use the wave property.

The airbrush is an excellent instrument for such fantastical, abstract, and theoretical renderings. In technical drawing the artist generally describes motion with arrows. Using the softer airbrush medium enables the artist to achieve a subtler conveyance of the idea of motion (see Figures 11–1 and 11–2). The free airbrush trajectory in Figure 11–1 illustrates comet tails as a much milder form of energy than the trajectory in Figure 11–2, which conveys a more direct and powerful energy and relates to a more logical interpretation.

The same type of analysis can be made in the case of an atom's representation. Both Figures 11–3 and 11–4 show an atom composed of a nucleus and a number of electrons orbiting around it. The difference between the two figures is obvious; conceptual considerations have determined the two variations.

Finally, on a more whimsical note, the renderings of ghostlike creatures (Figures 11–5 and 11–6) are created purely with the free airbrush technique, with the exception of the brush and mask techniques needed for the eyes. The red used for the pupils in Figure 11–5 is, of course, symbolic, representing some kind of malevolent spirit. In Figure 11–6, where the ghost is meant to be benevolent, the red of the eye is dropped and the expression is friendly.

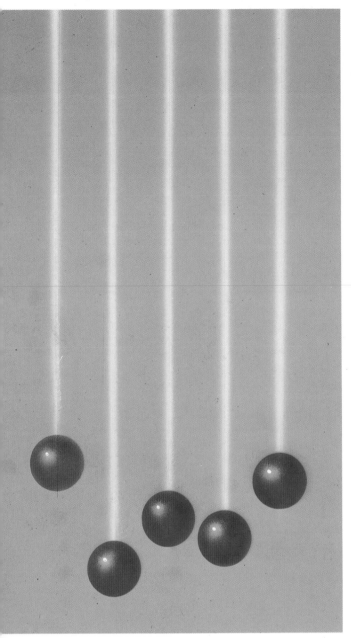

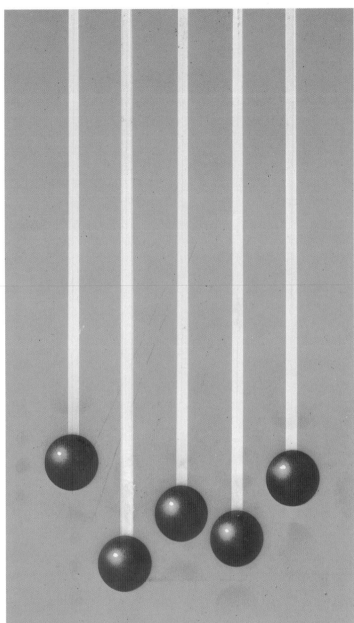

pport: 60W + 40Bk

ep 1: F (O) 100W R_2 D_{50}
ep 2: T (O) 100Rd$_3$ R_3 D_{100}
ep 3: F (O) 100W R_2 D_{50}
ep 4: B (O) 100W(highlight)

ote: In Step 1 use a ruler to guide your hand.

Support: 60W + 40Bk

Step 1: M (O) 100W R_2 D_{50}
Step 2: T (O) 100Rd$_3$ R_3 D_{100}
Step 3: F (O) 100W R_2 D_{50}
Step 4: B (O) 100W(highlight)

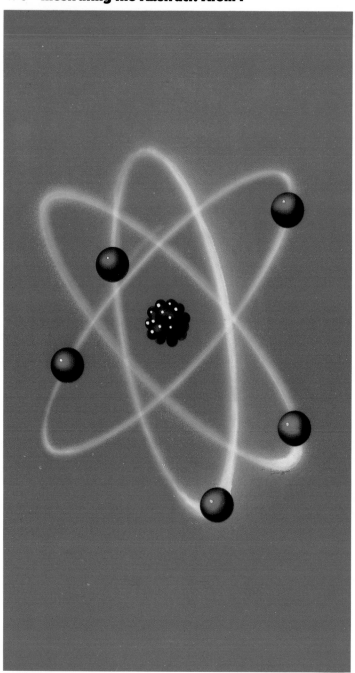

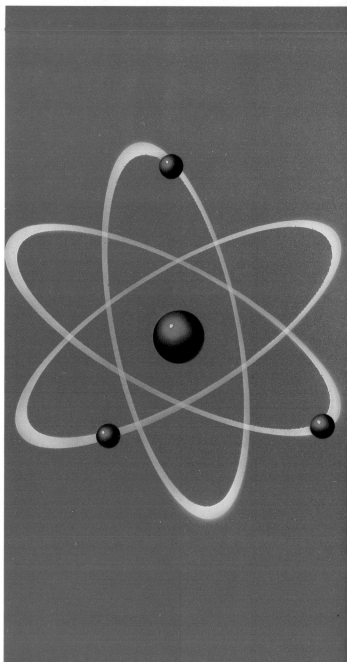

Support: $100Rd_1$

Step 1: ⒡ (O) 100W R_2 D_{50-80}
Step 2: ⓣ (O) 100Bk R_3 D_{100}
Step 3: ⒡ (O) $100G_1$ R_2 D_{60}
Step 4: ⒝ (O) 100W(highlights)

Note: Use elevated ellipse template for guiding the airbrush.

Support: $100Rd_1$

Step 1: ⓣ + Ⓜ (O) 100W R_2 D_{10-80}
Step 2: ⓣ (O) 100Bk R_3 D_{100}
Step 3: ⒡ (O) $100G_1$ R_2 D_{60}
Step 4: ⒝ (O) 100W(highlights)

Note: For each orbit, use template for ellipse together with acetate mask of smaller ellipse.

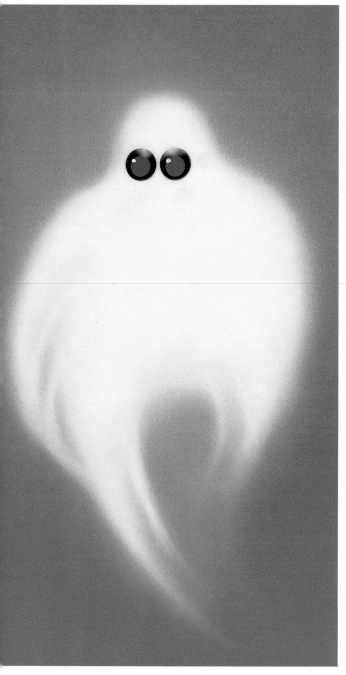

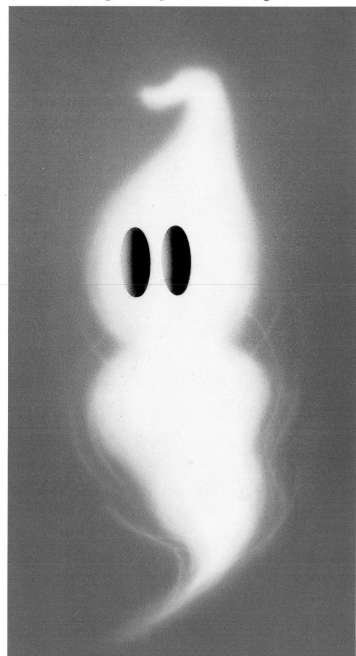

pport: 100Rd$_2$

ep 1: ☐F (O) 100W R$_{2-4}$ D$_{0-100}$
ep 2: ☐T (O) 100Bk R$_2$ D$_{100}$
ep 3: ☐T (O) 100Rd$_1$ R$_2$ S
ep 4: ☐B (O) 100W

Support: 100Rd$_2$

Step 1: ☐F (O) 100W R$_{2-4}$ D$_{0-100}$
Step 2: ☐T (O) 100Bk R$_2$ D$_0$ → D$_{100}$

Part Three

Concepts

Chapter 12

The Emotional Range of Airbrush

In the first two parts of this book, it is demonstrated that visual and conceptual information can be analyzed and understood logically and then assembled, combined, interpreted, recorded, and reproduced. So for the airbrush retoucher or for the commercial artist who has to reproduce his surroundings with high fidelity, the book may end here. But if you wish to become an airbrush artist in the pure sense, you will read on. First, of course, you want to transcend logical information and delve into the world of fine art; you must be subjective. You must react emotionally to your subject and ask yourself: "How does this particular event affect *me*?"

It is my belief that the artist must create his own unique art. The question of sensitivity and the relationship between a particular event and the artist cannot be injected into the artistically inclined mind. The artist is either sensitive to a particular or universal event or indifferent to it, regardless of influence or interference of others. The artist, of course, can be influenced by logical conceptual information, but he or she brings a unique emotional contribution, an inevitable and indispensable conceptual ingredient to the molding of the final artwork.

Airbrush is a newcomer to the world of art, and it is often viewed with suspicion. It is interesting to speculate about the way painters of the past would have reacted to the airbrush medium. They were often in search of the ideal technique to create faultless transitions from light to shade and from one color to another. Would they have happily given up hours of brushwork for the ease of the airbrush?

The airbrush medium's relationship to art is analogous to the piano's to music: it provides the instrument for creating art. And because airbrush is a unique medium, with capabilities and properties special to it alone, the artist should investigate his or her needs from the medium. Is the airbrush capable of expressing the artist's feelings? And if so, how is the image created by the airbrush different from the same image created by other mediums?

These questions must be addressed by the serious airbrush artist. If you look at the various moods suggested in Figure 12–2, you can see that the very simplest component of an airbrushed image—line—can convey very different emotional states. Figure 12–3 shows the many ways airbrush can express mood through tonal variation. From a technical point of view, there is nothing new here; however, from the conceptual point of view, these surfaces become significant.

Figure 12–1 shows twelve examples of airbrushed colors that stimulate various feelings. The aim here is twofold: first, to confirm that airbrush is capable of rendering an infinite array of human feelings; and second, to show that a particular feeling expressed with a brush and the identical feeling expressed with the airbrush are *not* identical. In other words, a variation of media varies the message as well.

Remember, *airbrush does not always provide the solution*. Only when a message is better defined by using airbrush is airbrush recommended. The arbitrary use of airbrush often results in mannerism and certainly does not help an artist to progress.

If the results from the brush and the airbrush were identical, one would, of course, inevitably fall into disuse. But this is not the case. Brush and airbrush are both very much alive; they compete sometimes, they cooperate in most cases, and they continue to develop side by side.

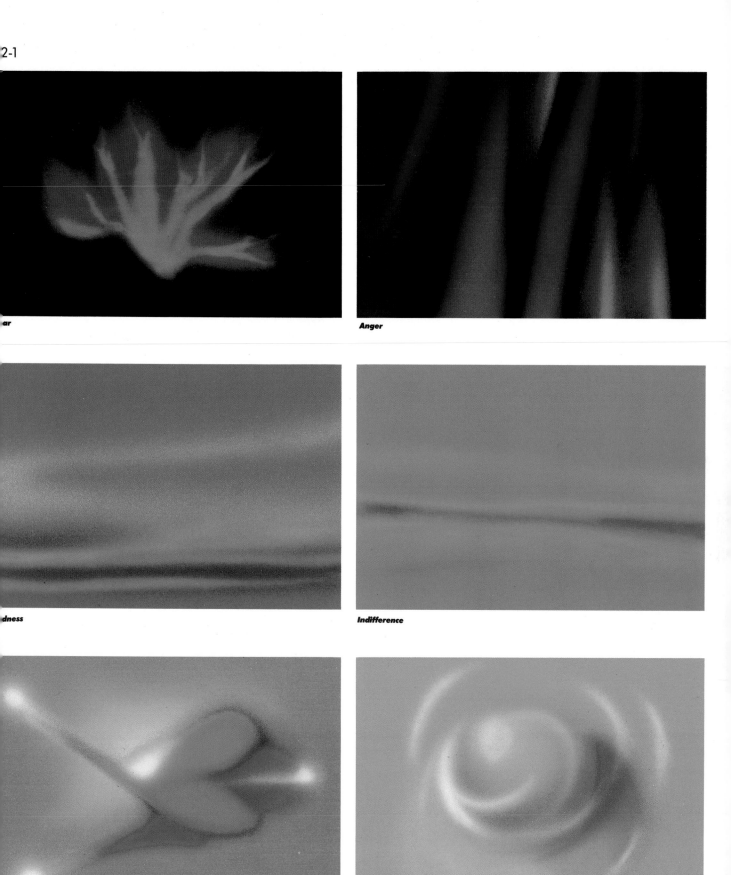

ar

Anger

dness

Indifference

opiness

Love

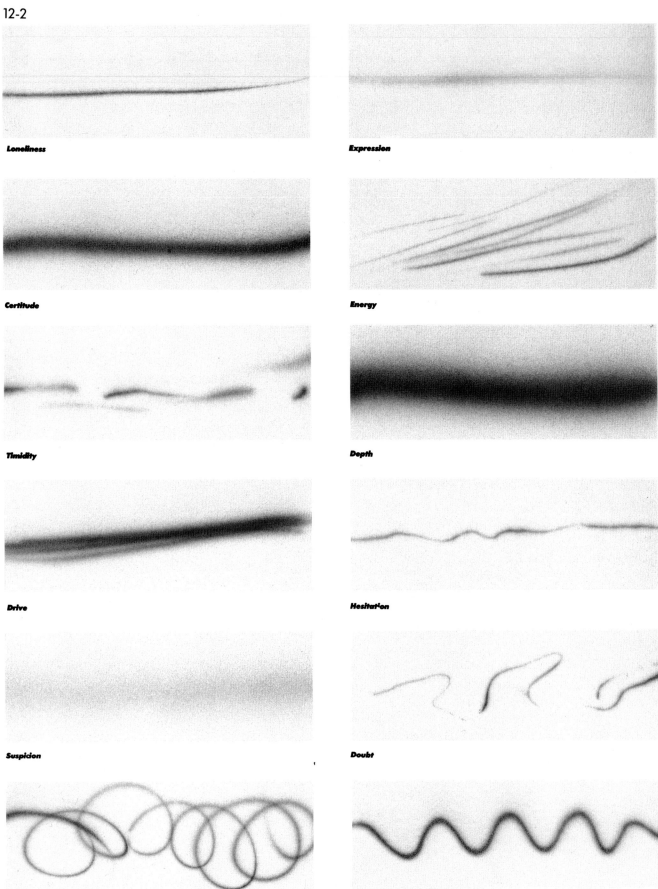

Loneliness

Expression

Certitude

Energy

Timidity

Depth

Drive

Hesitation

Suspicion

Doubt

Stress

Enthusiasm

spair

Hope

ssimism

Dizziness

lm

Depression

certainty

Forgetfulness

Chapter 13

Objective Realism

The next four chapters take you through four artistic-emotional styles that can be achieved through the airbrush medium: objective realism, subjective realism, nonrealism, and abstractionism.

The subjects chosen and analyzed throughout these four chapters are:

Theme 1. An English Victorian castle
Theme 2. Spread of bacterial infection in a kidney tubule
Theme 3. The owl
Theme 4. The male torso

The intention is to show the many possibilities open to the airbrush artist by demonstrating its use in different styles and in situations ranging from the calm and unemotional to the highly charged and emotional.

*O*bjective realism is an interpretation of reality that relies on logic to convey its message. The impact upon the observer is the result of a logical communication of the concept. Therefore, the analysis of each rendering will be based upon the emotional impact of the object on the artist.

In this chapter the four themes are approached realistically with the intention of conveying information in a logical manner.

THEME 1 (FIGURE 13-1)

Our imaginary artist, in search of beauty, is impressed by the geometric elegance and harmony of the castle. Another painter might be impressed by the stone structure or by the color harmony of the building within the landscape. In these cases, where the stone structure or the details of foliage would need to be realistically treated, airbrush would have no part. But our artist responds to the geometry of the structure; he likes the play of light and shadow, and he wants to capture *his* view. Because the roundness of the towers is so elegant, and so precise, the artist decides to use the airbrush. Of course, there are details like the landscape and the bridge that must be completed in brush. But the main structures will be rendered in airbrush.

THEME 2 (FIGURE 13-2)

The artist has an assignment to illustrate the bacterial infection of the kidney collecting tubule. It is to be the first page of a brochure promoting an antibacterial drug. The illustration has two functions: It must show the physician-reader the exact location of the cellular tissue in the collecting tubule, where the bacteria will locate and attack; and it must prepare the physician-reader for the next page of the ad where the drug will be demonstrated as beneficial.

The artist must approach this subject with a great deal of scientific accuracy. He is not emotionally impressed by the subject, so his artistic concept is mostly logical. In order to generate a very clear and scientific image (in his opinion, the best way to communicate the message), he decides to show a section of the tubule wall and a cluster of bacteria swarming over it. For this he will use both brush and free-hand airbrush. The artist must have a basic understanding of the anatomical detail he depicts. He chooses airbrush for this illustration because of the accuracy he thinks he can achieve, which will render the bacteria's fragility and the special quality of the cellular tissue.

THEME 3 (FIGURE 13-3)

The most striking and memorable characteristic of the owl is its eyes. When thinking of the owl, it's easy to forget about its shape, color, and texture. Our imaginary artist thinks this way, too, and his version concentrates mainly upon the eyes of the bird. He sees them as lively, deep, and powerful, with a keen instinct for prey. A truly realistic rendition would eliminate the use of airbrush because the feathers, beak, and legs require minute brushwork unobtainable with airbrush. But our artist cares little about rendering the owl realistically. For him the body is secondary; the eyes are his concern. In order to obtain the desired effect the artist will use free airbrush for the body of the bird, and then accentuate the eye area with the shield technique.

THEME 4 (FIGURE 13-4)

Here, our artist is impressed by the classical beauty of the male torso. He recalls figures in ancient Greek art. In his mind the torso becomes sculptural—a symbol of the endurance of the human species. He decides to use the airbrush because of the smooth continuity and the sculptural slickness he can achieve.

Since the artist is thinking of a sculptural form—a definitely outlined body—he will have to use an outline mask. When considering the material of his sculpture, he hesitates between marble and bronze; for him each material has a distinct interpretation. He decides on marble, which for him adds an element of elegance to the sculpture. His choice is subjective, of course. He feels that bronze would imply strength, which is not his aim.

Assignment

Consider theme 1, and, using the same basic imagery, imagine what would happen if your interest in the castle was triggered by color and not by geometry. In this case your rendering might be more freely drawn and the color harmonies more elaborate. Here, you will necessarily pay more attention to the choice of colors and to the factors of adjacency, ambiance, and counterlight than did our imaginary artist. However, you probably will use similar masks and methods, but because the outline precision and details are not your aim, you might end up using only the shield. Try it.

Support: $80Bl_4$ + 20W

Step 1: 🄵 (O) $80G_1$ + $20Y_2$ R_4 D_{100} ↑ D_0

Step 2: 🄼 (O) 80W + $10Br_5$ + $10G_1$ D_{100}

Step 3: 🄼 + 🄵 (O) $100Br_5$ R_{2-3} D_{0-100}

Step 4: 🄼 (O) 60W + 30Bk + $10Bl_5$ R_3 D_{100}

Step 5: 🄵 (O) 100W R_2 D_{100} → S

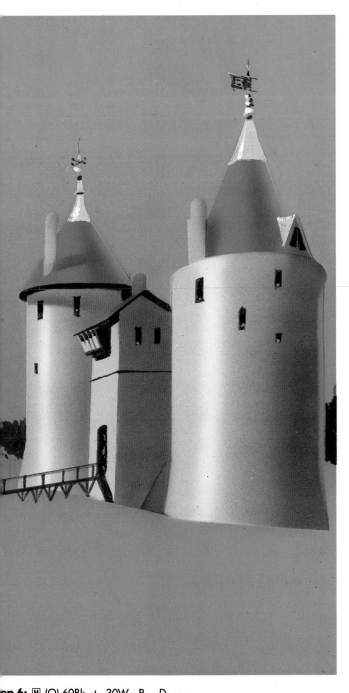

ep 6: Ⓜ (O) 60Bk + 30W R$_2$ D$_{0-100}$
ep 7: Ⓑ (O) 80Br$_2$ + 20Bl$_5$(structure details)
ep 8: Ⓑ (O) 70W + 30Bk(tops)
ep 9: Ⓑ (O) 100Bk(depths)
ep 10: Ⓑ (O) 100W(highlights)

Step 11: Ⓑ (O) 80W + 20G$_1$(lines)
Step 12: Ⓑ (O) 100G$_4$(shadows)
Step 13: Ⓑ (O) 80G$_4$ + 20Y$_1$(first step trees, use toothbrush)
Step 14: Ⓑ (O) 90Y$_1$ + 10G$_1$(second step trees, use toothbrush)

Note: The light tops should also be sprayed, but brush treatment adds solidity of structure. The details might be more elaborated, not so sketchy. The large 100G$_4$ shadow should be even if sprayed.

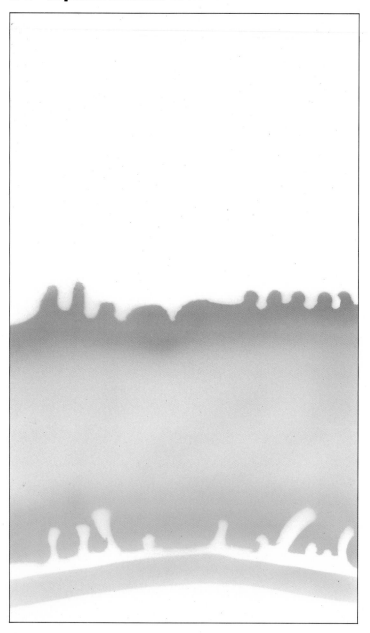

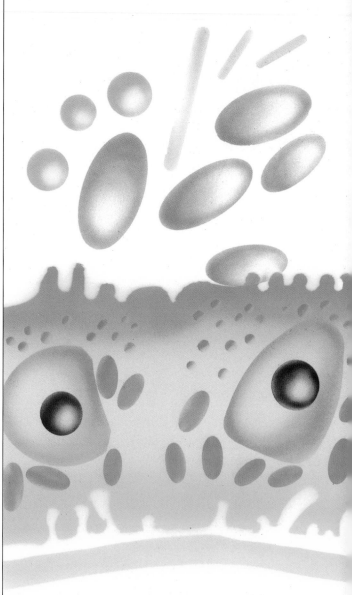

Support: 100W

Step 1: Ⓜ (O) 60W + 40Co R_{2-4} D_{20-100}
Step 2: Ⓜ (O) 40W + 50Co + 10Y$_3$ R_3 D_{100} ↓ D_0

Step 3: Ⓜ (O) 40Br$_5$ + 20Co + 40W R_3 D_{60-0}(nucleus of cell)
Step 4: Ⓜ (O) 30Bk + 10Y$_3$ + 60W R_2 D_{100-0}(bacteria)
Step 5: Ⓜ (O) 90W + 10V R_2 D_{100-0}(bacteria)
Step 6: Ⓜ (O) 10Rd$_2$ 90W R_2 D_{100-0}(bacteria)
Step 7: Ⓜ (O) 30Br$_5$ + 20Rd$_2$ + 50W R_{1-2} D_{100-0}(small shapes within cells: organelles)
Step 8: Ⓜ (O) 50Bk + 5Y$_3$ + 45W R_2 D_{100-0}(dark cell center: nucleolus)

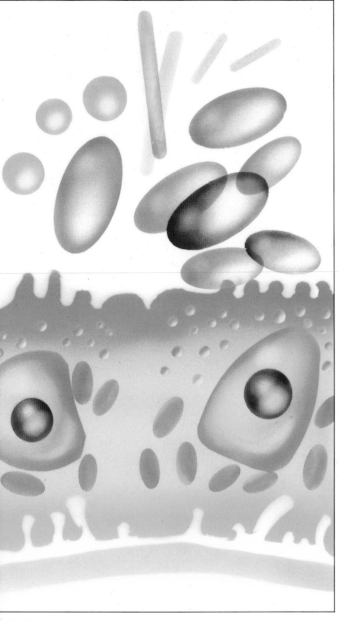

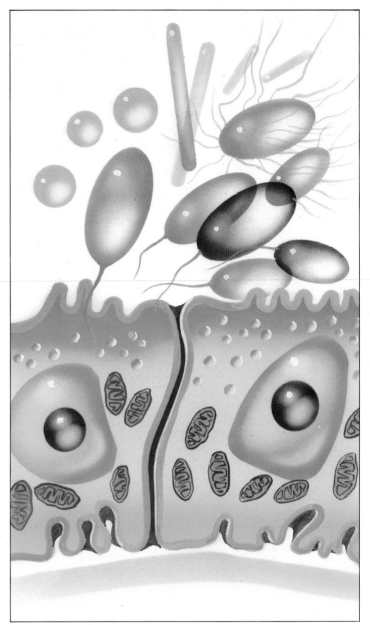

p 9: Ⓜ (O) 80W + 20V(overlapping bacteria)

p 10: Ⓜ (O) 50Bk + 5Y₃ + 45W(overlapping bacteria)

p 11: Ⓕ (O) 100W R₂ D₈₀

Step 12: Ⓑ (O) 50Y₃ + 30Co + 20Br₅(exterior outline of cell membrane)

Step 13: Ⓑ (O) 50Br₅ + 50Rd₂(dark areas)

Step 14: Ⓑ (O) 50Bk + 5Y₃ + 45W(gray markings on small cell parts: mitochondria)

Step 15: Ⓑ (O) 30Bk + 10Y₃ + 60W(bacteria tails)

Step 16: Ⓑ (O) 100W(highlights)

13-3 Objective Realism: Owl

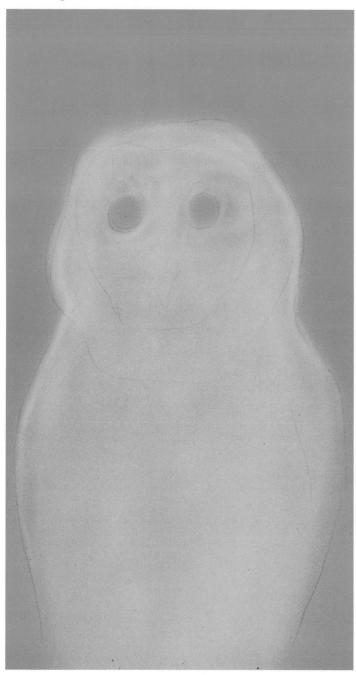 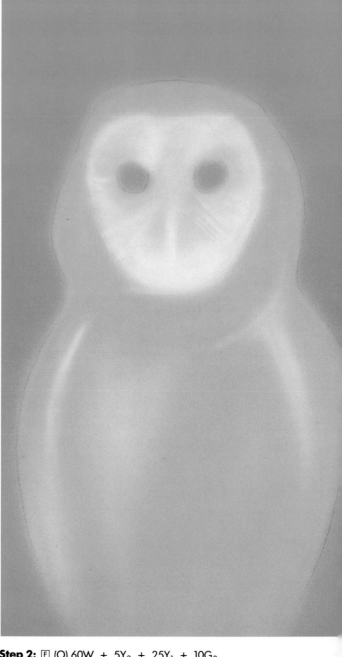

Support: 100G₁

Step 1: Ⓕ (O) 90W + 10Y₃ R₂₋₃ D₄₀₋₈₀

Note: This spray was done only superficially to preserve the visibility of the pencil transfer lines.

Step 2: Ⓕ (O) 60W + 5Y₃ + 25Y₁ + 10G₃

Step 3: Ⓕ + Ⓢ (O) 100W R₁₋₄ D₀₋₁₀₀

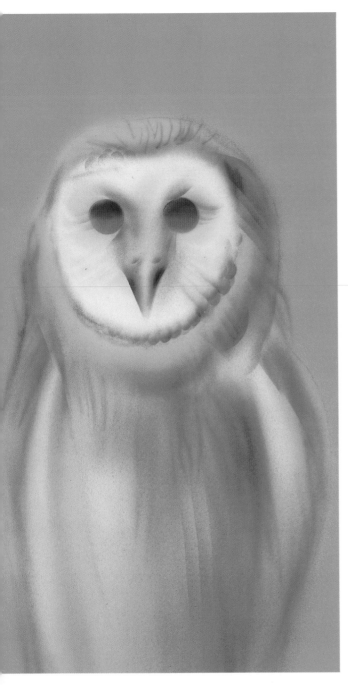

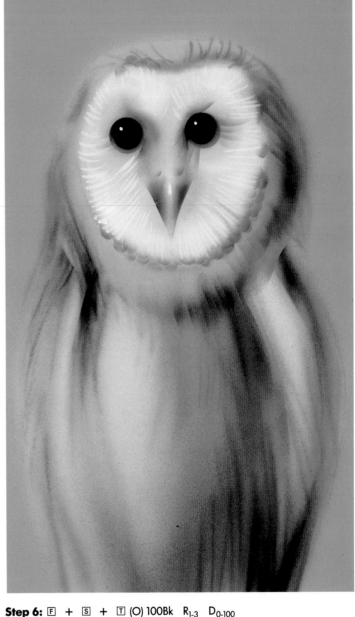

ep 4: �F + ⓢ + ⊤ (O) 60Br₅ + 40 Step 2 R₁₋₃ D₀₋₁₀₀
ep 5: �F + ⓢ + ⊤ (O) 100Br₅ R₁₋₃ D₀₋₁₀₀

te: In Step 4 the notation 60Br₅ + 40 Step 2 indicates that 60Br₅ is to
be mixed with the color used in Step 2, but in ratios of 60 and 40.

Step 6: �F + ⓢ + ⊤ (O) 100Bk R₁₋₃ D₀₋₁₀₀
Step 7: Ⓑ (O) 100W

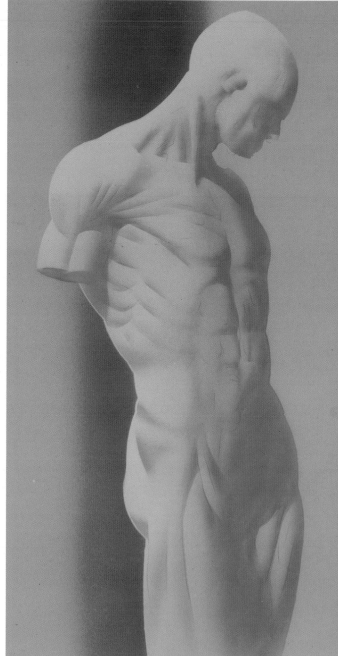

Support: 25Bk + 5Y$_3$ + 70W

Step 1: Ⓜ (O) 90W + 5Bl$_2$ + 5Co R$_3$ D$_{100}$

Step 2: Ⓜ (O) 40W + 25Bl$_2$ + 25Y$_2$ + 10Rd$_3$ R$_3$ D$_0$ ← D$_{100}$

Note: The masks used for Steps 1 and 2 are counterparts of the same cutting.

Step 3: Trace pencil details (transfer)

Step 4: Ⓢ (O) 60W + 10Rd$_3$ + 15Y$_3$ + 15Bl R$_{1-2}$ D$_{0-100}$

Note: Because the color used in Step 2 is too green to suggest marble, the color indicated for Step 4 is meant to correct the greenish cast.

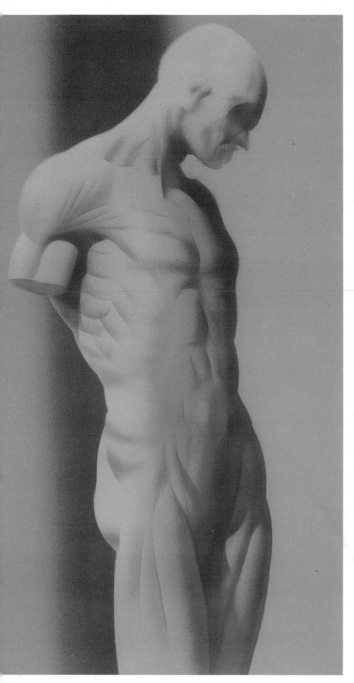

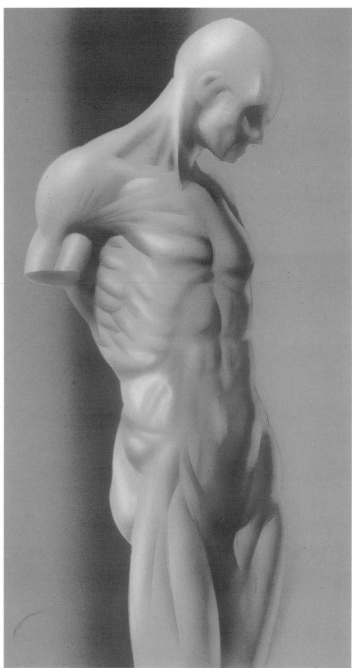

ep 5: Ⓢ (O) 40W + 30Bl₂ + 30Br₂ R₁₋₂ D₀₋₁₀₀

Step 6: Ⓜ + Ⓢ (O) 80W + 10Bk + 10Bl₂ R₁₋₂ D₀₋₁₀₀
Step 7: Ⓢ (O) 100W R₁₋₂ D₋ₛ₋₀

Chapter 14

Subjective Realism

In this chapter the artist's emotions play a larger part in the construction of the concept. The message, although still realistic, reflects the artist's emotional reactions and the artwork will become more dramatic. The object is no longer simply an object but the symbolic carrier of an emotional idea. To illustrate, let's return to our four themes and analyze each of them, along with the development of the renderings.

THEME 1 (FIGURE 14–1)

Let us assume that our imaginary artist is a great lover of gothic literature and movies. The serene vision of objective realism is replaced now by an eerie night view. The castle impresses him as a haunted mansion; he imagines the building swarming with ghosts and vampires. His vision embodies fear and superstition. The shapes of the castle are hinted at, preserving the original design and proportions, but without unnecessary structural details. A blanket of fog blurs reality even more. Lifeless tree branches (nonexistent in reality but realistically rendered) accentuate the sinister atmosphere. The presence of disembodied spirits is suggested by one cold light emanating from a window.

For all these haunting effects, there is no technique better than airbrush. The mask is used minimally for the scant outlines of the structure. The shield provides ghostly definitions of moonlight on the castle. The fog is obviously done with free airbrush as is the cold light from the window. Only the gnarled and lifeless tree branches are rendered with the trembling twists of a brush.

THEME 2 (FIGURE 14–2)

Unlike the factual representation of the kidney tubule, the artist is asked here to illustrate the idea of danger. He must convey the danger of untreated or neglected bacterial colonies in the renal tubule, so that, in the following pages of the advertising brochure, the drug will be demonstrated as highly effective in the fight against infection.

Each artist, of course, has his own vision of danger. For our artist the danger is represented by cellular destruction. But he must "dramatize" the destructive process by introducing—into the realistic, accurate images of the bacteria and tubule—stimuli that are associated in our mind with danger. These can be the color red, suggesting burning; the color green, suggesting poison; radial light beams, representing explosion; sinuous shapes, reminiscent of a snakelike creature's movements, etc. In the end, however, our artist chooses the color green because a concentration of bacteria in the tubule seems more a kind of poisoning than a "red" inflammation. Also, the color red portends a less dangerous situation than a prolonged infection. The illustration proves his point.

This exercise exemplifies some of the differences between the commercial artist and the fine artist. When a commercial artist receives an assignment, he elaborates his concept by first identifying with the reader. In this way the artist can understand and visualize which image might have an impact. (A commercial artist incapable of this identification has little chance of functioning as a conceptual artist.)

The fine artist, on the other hand, has no *intentional* identification with the reader. He works for his own vision; the assemblage of stimuli results from his involved sensitivity. He tends to be more a philosopher than a psychologist.

THEME 3 (FIGURE 14-3)

Our imaginary artist is impressed this time by the wisdom of the owl. He decides to transform the owl into a symbol of universal wisdom. Here, our artist tries to suggest universality by gradually fading the bird's body into the surrounding sky. The body's vertical symmetry symbolizes equilibrium. The blue light shining from its head represents the inherent source of wisdom. The eyes, he feels, must be designed so that the fierceness is replaced by a meditative depth and even the beak should lose its menacing shape and become more inconspicuous. Although a moderate amount of brushwork is unavoidable, the airbrush effects are crucial.

THEME 4 (FIGURE 14-4)

How do we represent vitality? Our artist believes that a male torso, even truncated as it is here, can symbolize life. Whether a commercial or fine artist, his interpretation might be similar, as long as his concept of the life force is one that stresses the body's attitude and muscular tension. Then, because dynamic energy is the main artistic concern, the body will lose its formal outline, and from its soft-edged shape—using free airbrush—emanates light.

Assignment

Take theme 2, the bacterial infection, and alter the concept. Instead of just illustrating the feeling or expression of the poisoned tubule, you must also show the advantages of using the drug advertised. Thus, the illustration shows the bacterial colony attacking the tubule's surface *and* the drug action in turn destroying the bacteria.

In order to carry out this assignment, you will need a concept to follow—one that will make this particular artistic concept an effective ad. This concept is described as follows: a kidney tubule, which is tubelike, is seen from inside and in deep perspective, like a subway tunnel seen from the rails. Here and there colonies of bacteria cover the cellular wall. From the depths of the tubule (or tunnel) appears the drug—seen as pills, capsules, light beams, or spherical bullets—that attacks the colonies and destroys them. Except perhaps for the image of the drug working on bacteria, everything remains realistic.

Support: 50Bl₁ + 50G₁

Step 1: F (O) 50V + 25W + 25Bk R₂₋₈ D₁₀₀ ↑ D₀
Step 2: F (O) 80Rd₄ + 20V R₃ D₁₀₀ − S

Step 3: M (O) 100Bl₅ R₃ D₁₀₀
Step 4: M + S + F (O) 40W + 40Bl₅ + 10W + 10Bk R₂
D₁₀ − S

Note: In order to make the atmosphere more sinister looking, Step 2
should be mixed with a little Bk and W, and Step 3 should reduce its
Bl brilliance by adding a little Bk and G₁.

Step 5: $\boxed{\text{F}}$ (O) 50V + 30W + 20Bk R_2 D_{80}
Step 6: $\boxed{\text{B}}$ (O) 60W + 40G_1(window)

Step 7: $\boxed{\text{F}}$ (O) 65W + 35G_1(window)
Step 8: $\boxed{\text{B}}$ (O) 100W

Support: $100G_4$

Step 1: Ⓜ (O) $100Y_3$ R_3 D_{100} (uniform color)
Step 2: Ⓜ (O) $80Y_3$ + $20W$ R_3 D_{100} ↑ D_0

Step 3: Ⓜ (O) $80Br_4$ + $20Y_3$ R_2 $D_{100\text{-}0}$ (nucleus of cell)
Step 4: Ⓣ (O) $70Br_4$ + $30G_4$ R_2 $D_{100\text{-}0}$ (dark cell center: nucleolus)
Step 5: Ⓕ (O) $80Rd_4$ + $20W$ R_2 D_{100}

Note: For Step 5, use mask for precise location.

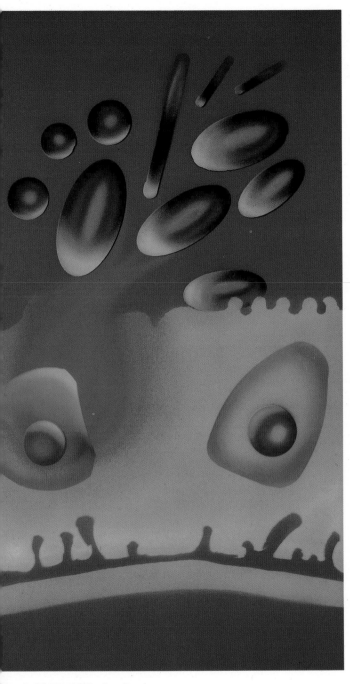

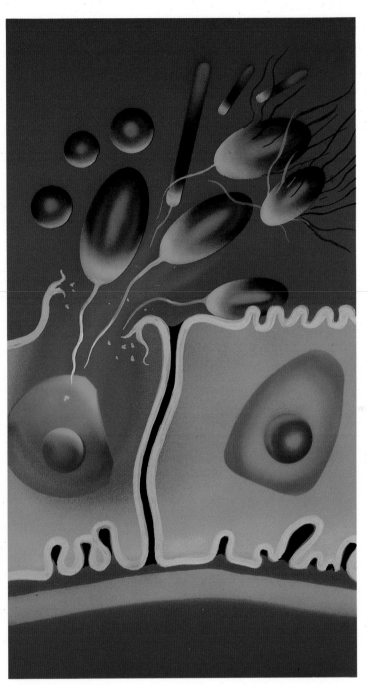

Step 6: \boxed{M} (O) 100Bk R_2 D_{100-0}
Step 7: \boxed{M} (O) $50G_4$ + 50W R_2 D_{100-0}
Step 8: \boxed{M} (O) $50G_1$ + 50W R_2 D_{5-0}

Step 9: \boxed{B} (O) 100Bk
Step 10: \boxed{B} (O) 50W + $25Y_3$ + $25Rd_4$
Step 11: \boxed{B} (O) $50G_1$ + 50W(bacteria tails)
Step 12: \boxed{B} (O) $25G_1$ + 75W(bacteria tails)

Note: In order to enhance dramatic effect, unnecessary details have been deleted.

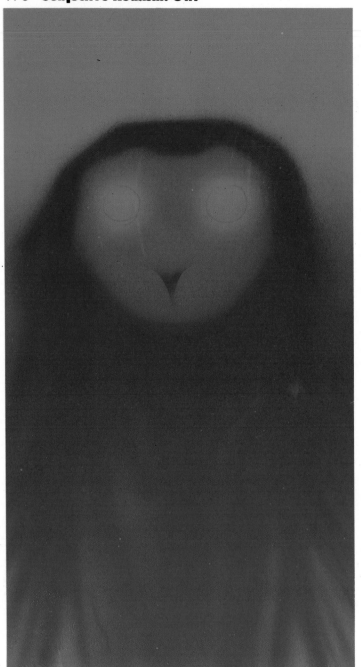 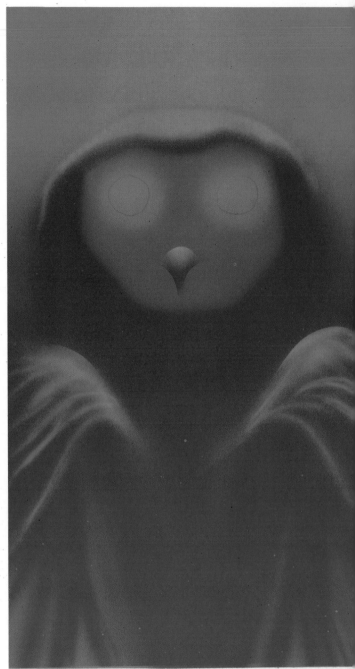

Support: 50G$_1$ + 50Bl$_4$

Step 1: Ⓕ (O) 50Bl$_4$ + 50W R$_3$ D$_{100}$
Step 2: Ⓕ (O) 100Bl$_2$

Step 3: Ⓕ (O) 70W + 30Bl$_2$ R$_{2-3}$ D$_{0-100}$
Step 4: Ⓢ (O) 70W + 30Bl$_2$ R$_1$ D$_{100}$ ↓ D$_0$(beak)

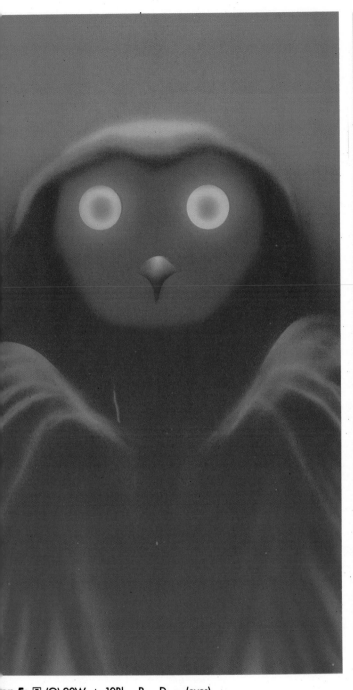

ep 5: ⊤ (O) 90W + 10Bl₃ R₂ $D_{100\text{-}5}$(eyes)

ep 6: ℉ (O) 90W + 10Bl₃ R₂ D_{60}(head)

ep 7: Ⓢ (O) 90W + 10Bl₃ R₂ D_{80} ↓ D_0(beak)

Step 8: ⊤ (O) 100Bk R₂ D_{100}(eyes)

Step 9: Ⓢ (O) 100Bk R₂ $D_{0\text{-}100}$(beak, face, and body)

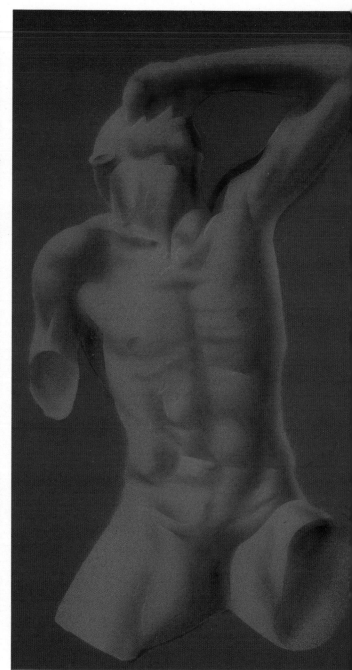

Support: 100Br$_5$

Step 1: $\boxed{\text{M}}$ (O) 100Rd$_1$ R$_4$ D$_{100}$

Step 2: $\boxed{\text{S}}$ (O) 100Rd$_5$ R$_{1\text{-}2}$ D$_{0\text{-}100}$

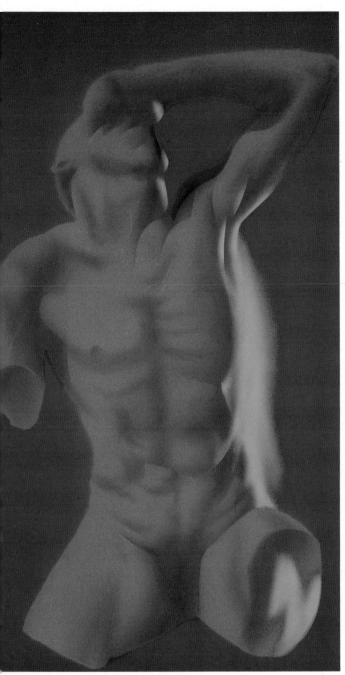

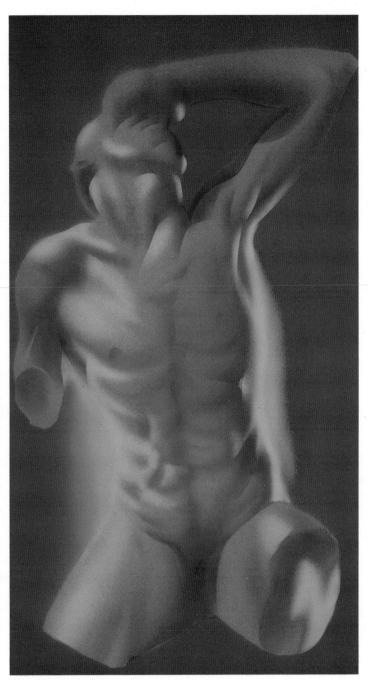

ep 3: Ⓢ (O) 50W + 50Bl₃ R₁₋₂ D₀ S

Step 4: Ⓢ (O) 80Y₁ + 20Co R₁₋₂ D₀ S

Chapter 15

The Nonrealistic Approach

The beginning of the twentieth century witnessed a revolutionary transformation of the relationship between logic and emotion in the visual arts. Before this even impressionism, with all its courageous detachment from classical painting, remained faithful to the realistic representation of subjects. A great number of theories and schools, collectively called the avant-garde, espoused—with their slogans, creeds, and experimentational efforts—the need to increase subjectivism in art. Perhaps Picasso said it best: "I paint things as I think them, not as I see them."

The avant-garde movement attracted thousands of people for whom the elimination of "realism" is a bonanza that can be stretched limitlessly. The interest in nonrealistic art for airbrush artists can be summarized in two statements:

1. The nonrealistic approach to art has the great merit of showing us that beyond the visible world there are other visions that when translated into art generate a universe of messages.

2. Nonrealistic imagery can be substantially enriched with the use of airbrush. However, the airbrush artist should not adopt nonrealistic style for the sake of it; rather, he should use the airbrush because the message cannot be properly communicated without it.

Let us return to the four themes and follow our imaginary artist's thought processes. What is in his mind and imagination that guides him to the airbrush?

THEME 1 (FIGURE 15–1)

Our artist is impressed this time by the ingenious assemblage of shapes that constitutes the castle. He wants to represent, in a surrealistic manner, the "process" of assembly. The artist is not interested in nature or the environment in general. He wants to express his vision about a *magical* constructive process—a process that has nothing to do with reality. In order to stress the motion of assembly, he will use a steep perspective, which is often characteristic of surrealism. He will also indicate the direction of this motion by adding tails to the uniting solids.

Our artist is aware that the visual representation of his idea will be too fragmented to read unless he strengthens its credibility by including realistic details. Therefore, the building parts will be treated in a very smooth, precise, and detailed way, almost like photographs of real parts, a technique readily obtained with airbrush.

THEME 2 (FIGURE 15–2)

Our artist perceives that the bacterial invasion symbolizes the eternal fight for survival. He realizes that bacteria, man, and all forms of life survive because of their environment, regardless of the destruction they inflict upon it. The bacteria become symbolic beings—in his imagination and on paper—and more figurative than they actually are.

To stress rapacity, the artist visualizes the bacteria as having greedy eyes. Also, because many bacteria possess thin, elongated extensions on their bodies called villi, the artist will use the villi in a distorted manner, giving them the shape of spider legs. In implementing this idea, the airbrush has a secondary role. However, the theme now has nothing to do with a medical promotional illustration, but becomes the visual statement of a particular mental process, similar to the mental processes occurring in artists like Hieronymus Bosch and M. C. Escher.

THEME 3 (FIGURE 15-3)

Under the influence of a Kafkaesque fantasy, our artist imagines himself a very small animal, under attack by the owl. This nightmarish scene generates a distorted image of the owl, which becomes a symbol of life-threatening forces beyond human control. In order to communicate his portrayal of terror, the artist uses a few powerful images to determine the entire composition. The perspective becomes one of a very small creature looking up at a terrifying image—not a "bird's-eye view" but a "worm's-eye view." Thus, the most powerful detail of the composition is the enormously distorted claws, enlarged not only by perspective but also by fear. The power of the message consists also in the accurate, realistic definition of these claws, in contrast with the rest of the body which distorts and shrinks dramatically toward a spatial vanishing point. The tail descends below the horizon line, symbolizing the endless and gigantic power of the threat.

The distant head becomes small, blurred, and unimportant. The complex wingspan (not entirely visible in our illustration) is treated in outlines reminiscent of the A-bomb's mushroom cloud—thus hinting at the real message of this work.

As you can see, this is a splendid opportunity for the airbrush artist to use a large spectrum of airbrush techniques, from the most rigid masking to the entirely free ones. Such a work could be implemented with a simple brush technique as well, but the effort would be considerably greater.

THEME 4 (FIGURE 15-4)

Our artist is in an impressionistic period. For him the male torso represents the fugitive relationship between light, object, and eye. Like many impressionists, he wants to capture the unique moment at which light and object interact and melt together in a unique color harmony. Unlike impressionism, however, where brushstrokes are loose and not carefully blended into each other, each spot of airbrush-applied color (as long as a shield is not used) blends inevitably with the adjacent ones. Depending upon the size and geometry of such airbrush strokes, the core of each color might remain pure or combine with the neighboring colors. The chromatic variations and richness of such a work could be many times greater than a work obtained with the brush, although the message would be completely different. For instance, instead of trying to obtain the vigorous feeling of freshness possible with the standard painting brush, the airbrush artist can obtain an iridescent smoothness.

Assignment

This assignment—the simplest and yet perhaps the most difficult to visualize—is to paint the male torso in an impressionistic style. By doing this you will get an idea of the full splendor of airbrush's chromatic vibrations.

Choose a 20″ × 30″ support. You will not be using a shield or a mask in this exercise. Your task here is not to spray, but to visualize the final harmony and the colors you are going to use to get your message across. (Preserve any left over colors in jars; you might need the same color here and there.)

Be cautious when selecting your colors but be spontaneous once you've decided. If later you feel your color scheme has failed, try to understand why it did (perhaps in the harmony of strokes, in color adjacency, or in an ill-defined message) and start over.

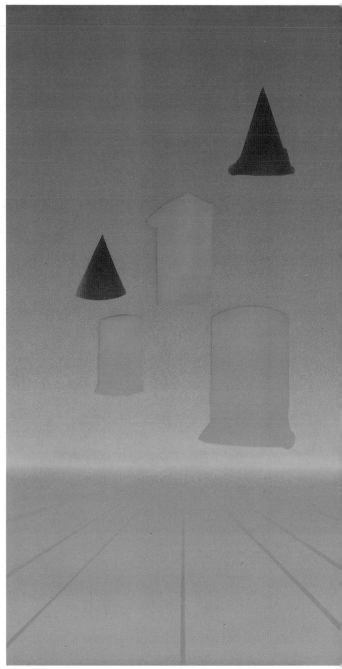

Support: $80Bl_4$ + $20W$

Step 1: F (O) $80Y_3$ + $20W$ R_2 D_{100} ↑ D_0
Step 2: B (O) $100Br_3$(perspective lines)
Step 3: F (O) $100Br_3$ R_4 D_{100} ↓ D_0
Step 4: F (O) $90W$ + $10V$ R_{2-5} D_{100} ↑ D_0

Step 5: M (O) $80Br_3$ + $20Y_3$ D_{100}
Step 6: M (O) $40W$ + $40Bk$ + $20Bl_4$ D_{100}

ep 7: Ⓜ + Ⓢ (O) 80Rd$_5$ + 20Br$_3$ R$_2$ D$_0$ ← D$_{100}$
ep 8: Ⓜ (O) 70Bk + 20Bl$_2$ + 10W R$_2$ D$_0$ ← D$_{100}$
ep 9: Ⓜ + Ⓕ 100W

Step 10: Ⓑ (O) 40W + 40Bk + 20Bl$_4$ D$_{100}$(small triangle)
Step 11: Ⓑ (O) 100Rd$_5$
Step 12: Ⓑ (O) 100Bk(within Rd$_5$)
Step 13: Ⓑ (O) 80Rd$_5$ + 20Y$_3$(reinforcing the perspective line)
Step 14: Ⓕ (O) 100W(trajectories)

Note: White trajectories (Step 4) do not go to the same vanishing point; some are much lower, at the horizon line. If the trajectories do vanish on the horizon, the castle parts should be parallel to the ground.

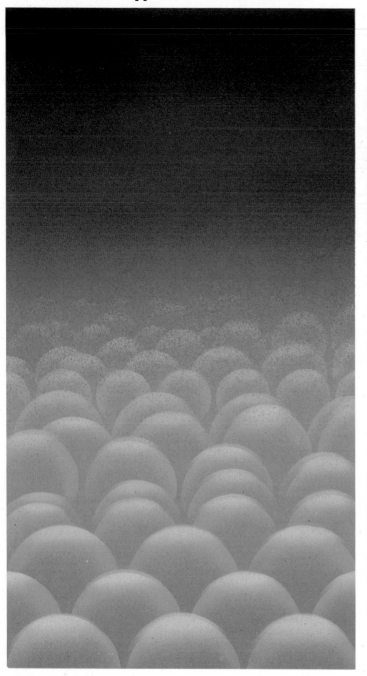

Support: $100Rd_1$

Step 1: Ⓜ (O) $60Co + 40Y_1$ R_2 D_{80} ↓ D_0
Step 2: Ⓜ (O) $40Co + 20Y_1 + 40W$ R_2 D_{80} ↓ D_0
Step 3: Ⓜ (O) $20Co + 10Y_1 + 70W$ R_2 D_{100} ↓ D_0
Step 4: Ⓕ (O) $100Rd_5$ R_5 D_{100} ↓ D_0

Step 5: Ⓜ (O) $80W + 20G_3$ R_3 D_{100}
Step 6: Ⓜ (O) $40W + 10G_3 + 50Rd_5$ R_2 $D_{0\text{-}100}$

p 7: Ⓜ (O) 40Co + 20Y$_1$ + 40W R$_2$ D$_0$ ← D$_{100}$
p 8: Ⓜ + Ⓣ (O) 100W R$_2$ D$_{0-100}$

Step 9: Ⓑ (O) 100W(pupil highlights)
Step 10: Ⓑ (O) 40W + 10G$_3$ + 50Rd$_5$(legs)
Step 11: Ⓑ (O) 100Rd$_5$(foreground figure's legs)

Note: Spraying Step 4 first and then Steps 1, 2, and 3 would have resulted in another concept. Here, the menacing brown mood covers the cell floor, instead of being covered by it.

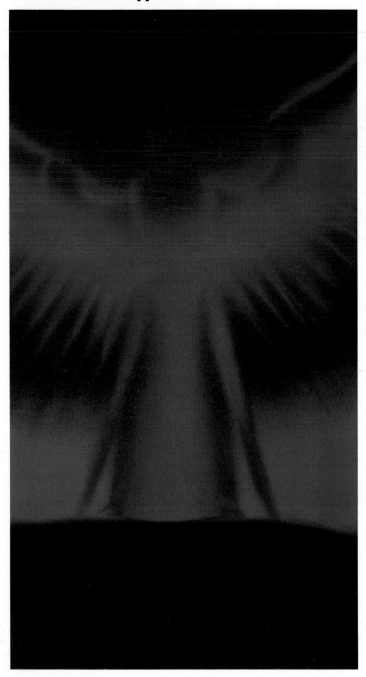

Support: 100Bk

Step 1: Ⓕ (O) 100Rd$_2$ R$_2$ D$_{100}$ ↑ D$_0$
Step 2: Ⓕ (O) 80Bk + 15W + 5Y$_3$ R$_2$ D$_{0\text{-}100}$
Step 3: Ⓕ + Ⓢ (O) 60Bk + 30W + 10Y$_3$ R$_2$ D$_{0\text{-}100}$

Step 4: Ⓕ + Ⓢ (O) 50Bk + 45W + 5Y$_3$ R$_2$ D$_{0\text{-}100}$
Step 5: Ⓕ + Ⓢ (O) 100Co R$_2$ D$_{0\text{-}100}$

Note: It's a good idea to finish the entire background before going on to the details. Otherwise, your background may not have the complexity of tone you want in the final image.

ep 6: Ⓜ (O) 100Y₃ R₃ D₁₀₀

ep 7: Ⓢ (O) 80Br₅ + 20Y₃ R₂ D₀₋₁₀₀

ep 8: Ⓑ (O) 100Co(head)

ep 9: Ⓑ (O) 100Rd₁(head)

ep 10: Ⓑ (O) 100Bk(head)

ote: Airbrush can be used for the head details, but this scale is too small
 and requires a brush.

Step 11: Ⓜ (O) 100Bk R₂ D₁₀₀(claws)

Step 12: Ⓢ + Ⓕ (O) 90W + 10Bl₅ R₂ D₆₀

Step 13: Ⓑ (O) 100W(claws and eyes)

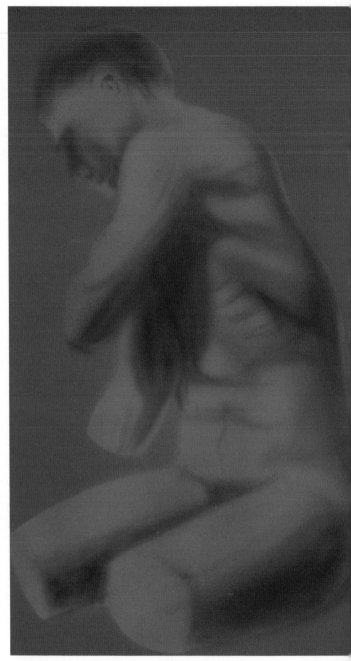

Support: $80Br_2 + 20Rd_5$

Step 1: Ⓜ (O) $80Br_2 + 20W$ R_4 D_{80}

Step 2: Ⓕ (O) $100Rd_5$ R_2 D_{100-0}

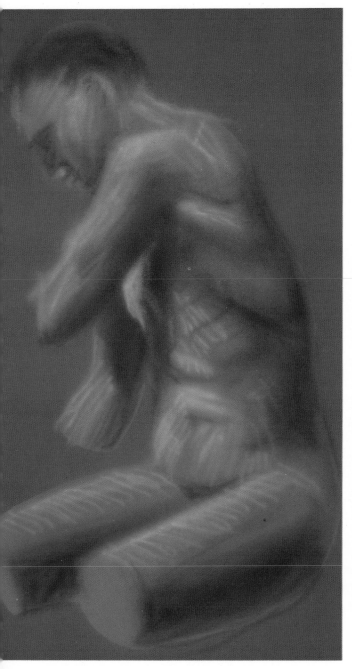

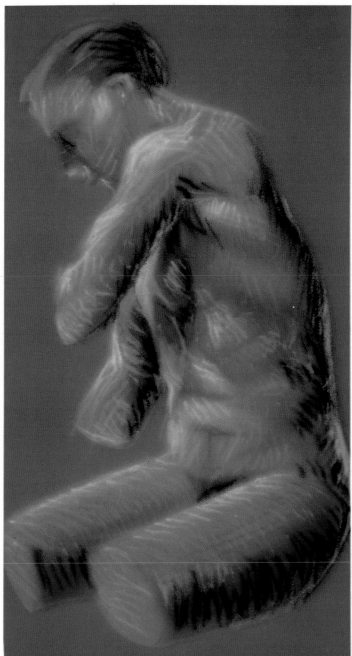

ep 3: F (O) 80Y$_1$ + 15Br$_2$ + 5W R$_2$ D$_{100-0}$

Step 4: F (O) 60Bl$_1$ + 40W R$_2$ D$_{0-100}$
Step 5: F (O) 85W + 15V R$_2$ D$_{0-100}$
Step 6: F (O) 85W + 15Rd$_1$ R$_2$ D$_{0-100}$
Step 7: F (O) 100Bl$_2$ R$_2$ D$_{0-100}$
Step 8: F (O) 70W + G$_2$ R$_2$ D$_{0-100}$(counterlight)

Chapter 16

The Abstract Approach

By definition, abstract art rejects any representation of an object. In Gina Pischel's *A World History of Art*, abstractionism is defined as ". . . the abandoning of a will to represent and the total invention of the work, which has no subject or meaning outside of itself." It has generated different groups, or schools, like geometric abstractions or lyrical abstractionism; and it has also merged with expressionism creating what is called abstract expressionism. But no matter what form abstract art takes, the basic idea is that relationships of form and color exist for themselves in spite of the vestigial remains of a subject.

Now, how do we relate the theory of abstraction to airbrush? Let us go back to our themes and see.

THEME 1 (FIGURE 16–1)
Our imaginary artist has become enamored of abstract art and forgets about the castle, although the impact of its geometry has left an indelible impression on him. So, he takes his airbrush and starts spraying color after color spontaneously, but is conscious at some level that what he paints is an assemblage of stimuli abstracted from the memory of the castle's forms.

THEME 2 (FIGURE 16-2)

What do you feel when thinking of bacterial infection? Unless you are a scientist and interested in bacteriology, your feelings about this idea will be apprehensive or fearful, and the visual transformation of this state of mind can take many forms. In our example, the artist's choice of imagery reveals insidious lines and streaks of color, which signal his interpretation of apprehension. But in this case, the realm of complete subjectivism has been reached. Nothing is logical or definitive.

THEME 3 (FIGURE 16-3)

For our artist the owl provides a rich source of abstractions: silence, intelligence, night, peace, cruelty. But for our artist it is enough if just one of these abstract ideas becomes the basis for an abstract work.

The artist begins by brushing in black streaks that suggest violent action. These streaks are then softened with the airbrush, combining the spontaneity of the brush with the soft fading technique of the airbrush. The result is an unusual harmony.

THEME 4 (FIGURE 16-4)

Let us suppose, in this instance, that our artist decides to abstract the male torso and create a powerful erotic tension on the canvas. The artist selects intense, hot colors to enhance this feeling and to indicate glistening skin, spatters droplets of light color with the airbrush. The result may not suggest eroticism to everyone, but for this particular artist the statement is made.

Assignment

Imagine a fragrance and translate that image into paint, using your own personal conception and not a standard image such as a flower or a smokey path radiating from a source. Remember that rendering an abstraction draws upon the same skills that you need when you paint realistically, but that certain elements in the painting may need to be emphasized. For example, when you portray an abstract idea, the background tends to take on extra importance because the subject matter is implied and not clearly stated. Color and shape are important elements as well as when the subject is not realistically portrayed.

Hint: Listening to music is an excellent way to coax images from your unconscious.

Support: 100W

Step 1: F (O) 100G$_1$ R$_3$ D$_{100}$
Step 2: F (O) 100Bl$_2$ R$_3$ D$_{100}$

Step 3: S (O) 100G$_2$ R$_{2\text{-}3}$ D$_{0\text{-}100}$
Step 4: T (O) 50W + 50Y$_1$ R$_2$ D$_{100}$ ↓ D$_0$

Step 5: ⊤ (O) $60Y_1$ + $40Rd_5$ R_2 D_{100} ↓ D_0
Step 6: ⊤ (O) $50G_2$ + $50W$ R_2 D_{100} ↓ D_0

Step 7: ⊤ + 🄵 (O) $100Bk$ R_2 D_{100} ↑ D_0
Step 8: ⊤ (O) $10V$ + $90W$ R_2 $D_{5\text{-}100}$

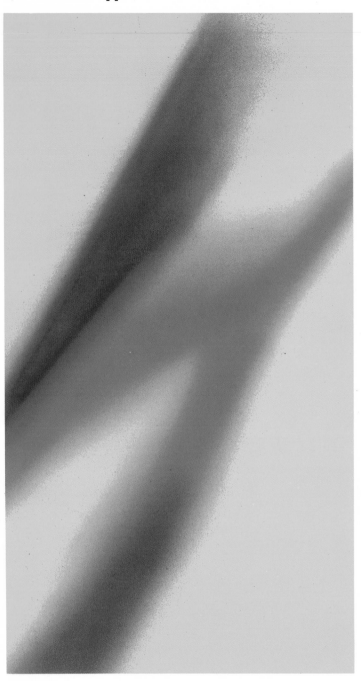

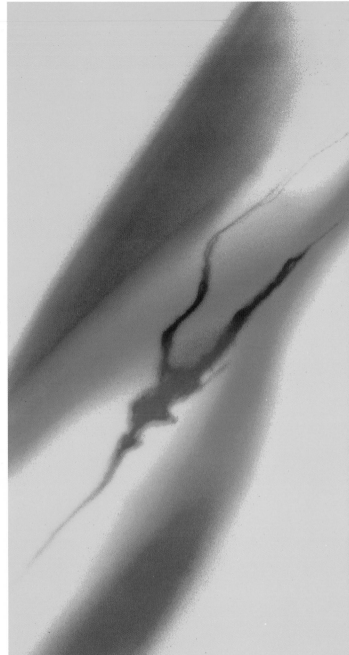

Support: 100Y

Step 1: ☲ (O) 30Rd$_5$ + 40G$_3$ + 30W R$_{2-3}$ D$_{100-0}$
Step 2: ☲ (O) 100G R$_{2-3}$ D$_{100-0}$
Step 3: ☲ (O) 100Bl$_4$ R$_{2-3}$ D$_{100-0}$

Step 4: ☲ (O) 100Rd$_3$

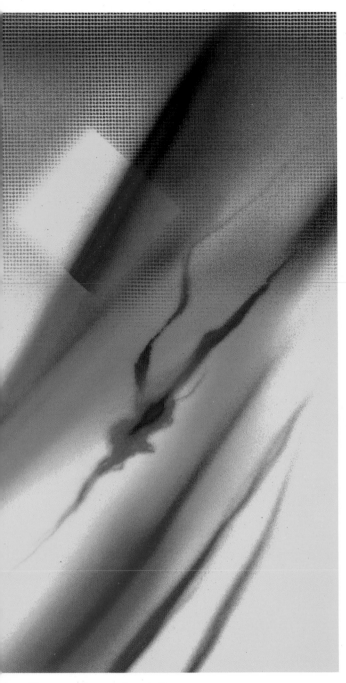

ep 5: Ⓜ (O) 100Rd$_5$ R$_4$ D$_{60}$ ↓ D$_0$

te: The mask in Step 5 is a plastic net.

ep 6: Ⓕ (O) 100Bl$_2$ R$_2$ D$_{80-100}$

Step 7: Ⓕ (O) 100W R$_2$ D$_{40-80}$

Support: 100Rd₁

Step 1: Ⓑ (O) 100Bk

Step 2: Ⓕ (O) 100Bk
Step 3: Ⓢ (O) 80W + 20Bl₄ R₂ D₁₀₀ → D₀
Step 4: Ⓢ (O) 100Y₁ R₂ D₁₀₀ → D₀
Step 5: Ⓢ (O) 50W 50Y₁ R₃ D₈₀ → D₀

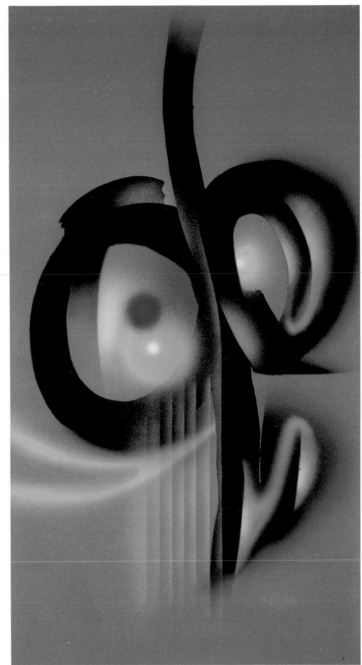

ep 6: F (O) 90W + 10V R₂ D₁₀₀
ep 7: F (O) 100V R₂ D₁₀₀

Step 8: F (O) 100W R₂ S
Step 9: S (O) 100W R₂ D₃₀

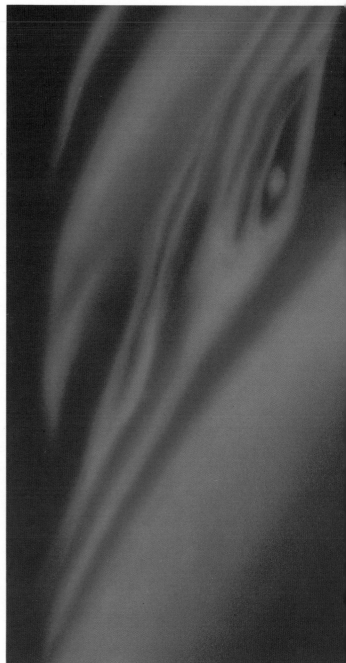

Support: 50Br$_5$ + 50Rd$_5$

Step 1: F (O) 70Rd$_3$ + 30Rd$_1$ R$_{2-4}$ D$_{100-0}$

Step 2: F (O) 60Y$_3$ + 30Rd$_3$ + 10Rd$_1$ R$_{2-4}$ D$_{0-S}$

Step 3: F (O) 100Rd$_1$ R$_2$ D$_{0-100}$

ep 4: ⑤ (O) 60Y$_1$ + 35Y$_3$ + 5Rd$_1$ R$_{2-3}$ D$_{100-0}$

ep 5: ⑤ (O) 40Bk + 10Bl$_2$ + 10G$_2$ + 10Y$_1$ + 30W R$_2$ D$_{100-0}$

Step 6: ⑤ (O) 95W + 5Bl$_2$ R$_4$ D$_{80-30-0}$

Note: For Step 5, reduce compression pressure to 3 to 5 pounds per square inch.

Index

Edited for Watson-Guptill by Candace Raney
Design by Damien Alexander
Graphic production by Ellen Greene
Text set in 11-point Helvetica Thin